IMAGES
of America

RIVERDALE PARK

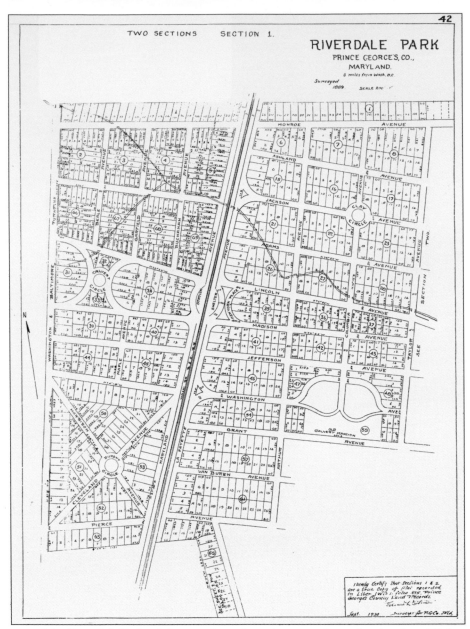

This map of the Riverdale Park subdivision shows how the town planned to develop. All the major roads converged at an easy access to a planned Baltimore & Ohio (B&O) commuter station. The town was laid out in a grid-like fashion, broken up with pocket park circles, often maintained by the Riverdale Park Women's Club. (Maryland Land Records.)

ON THE COVER: Pictured in 1957 at the annual fire department parade, the Mack 85LS-1573 fire truck was delivered to Riverdale, Maryland, on November 14, 1951, by the Mack Washington, DC, branch. According to Mack Museum curator Don Schumaker, "The Laureldale truck is truly a celebrity." The gentleman on the right-front running board is Jack McCord, who two years later became the Riverdale fire chief. (Courtesy John McCord.)

IMAGES
of America

RIVERDALE PARK

Donald Lynch, Tom Alderson, and
Melissa Avery on behalf of the
Historical Association of Riverdale Park

ARCADIA
PUBLISHING

Published by Arcadia Publishing
Charleston, South Carolina

Printed in the United States of America

Library of Congress Control Number: 2011922073

For all general information, please contact Arcadia Publishing:
Telephone 843-853-2070
Fax 843-853-0044
E-mail sales@arcadiapublishing.com
For customer service and orders:
Toll-Free 1-888-313-2665

Visit us on the Internet at www.arcadiapublishing.com

To the people of Riverdale Park, past, present, and future

CONTENTS

ACKNOWLEDGMENTS

Thanks to Susan Pearle and the staff at the DeMarr Library for the wonderful conversations we had about not only the history of Riverdale Park but also of the surrounding area and development of the region; Anne Wass at the Riversdale Mansion and Maryland–National Capital Park and Planning Commission for her access to the Riversdale Photographic Collection and for sharing her extensive knowledge of the mansion's history; Kate Buxbaum Prado for her stories about the Engineering and Research Corporation (ERCO) and her father's role at ERCO and for sharing his poetry; and Gerald King for the many long talks about art and life in Riverdale. Special thanks to all those who gave accounts of the old days in Riverdale Park, and especially to those who shared personal photographs with us.

HARP: Historical Association of Riverdale Park
LOC: Library of Congress
M–NCPPC: Maryland–National Capital Park and Planning Commission
PGCHS: Prince George's County Historical Society
TRP: Town of Riverdale Park

INTRODUCTION

The land under present-day Riverdale Park was laid down by the same meteor impact that created the Chesapeake Bay during the Eocene Period. As the continental ice sheets of the Wisconsin Glacial Epoch began to recede, a favorable climate and fertile soil provided a haven for the first humans who settled in this area, perhaps as early as 10,000 BC. For at least 7,000 years prior to contact with the Europeans, the Woodland Algonquin tribes had communities along the Paint Branch and Northeast Branch of the Anacostia River.

In March 1634, about 300 settlers, led by Maryland's first governor, Leonard Calvert, established Maryland as a settlement, St. Mary's City, on the Chesapeake Bay. Within 30 years, farms and plantations lined both the Patuxent and Potomac Rivers. Among the many indentured servants who worked the tobacco plantations was a six-foot-seven-inch-tall Scotsman named Ninian Beall. Beall rose from indentured servant to prominence and brought the extended Beall clan to Prince George's County. This clan owned most of Prince George's County and what is now Washington, DC, including the land that became Riverdale Park.

In 1794, Henri Joseph Stier and family left Belgium, fleeing the French Revolutionary wars. With him, he brought an impressive art collection that included works by Flemish masters Rubens, van Dyke, and Rembrandt, and the Italian Titian. After his daughter Rosalie Stier married George Calvert, delegate to the Maryland Assembly and direct descendant of the Lords Baltimore, the family decided to build a permanent home in Maryland.

In 1800, at the urging of his son-in-law George Calvert, Henri Joseph Stier acquired a 729-acre parcel at auction that would become the site of Riversdale Plantation. By 1802, the political climate had changed in Belgium, and the Stiers returned to their homeland. Rosalie and George Calvert moved into Riversdale.

During the War of 1812, Rosalie Calvert watched from her roof as the British invaders fired Congreve rockets at the American defenders. George Calvert carried supplies to the field hospital in Bladensburg. He and his field hands buried many of the dead from the Battle of Bladensburg.

Calvert's son Charles Benedict Calvert, an agricultural innovator, is considered the father of the University of Maryland, donating Rossborough Farm in 1856.

By the end of the 1800s, residents of Washington, DC, began moving out to the previously rural areas beyond its surveyed boundary. In 1887, the original Calvert tract sold to the newly formed Riverdale Park Company. Around the turn of the century, as trolley car lines extended north into Maryland, this migration to the suburbs accelerated. With the arrival of the streetcar, Riverdale began to coalesce around the train station built by the Riverdale Park Company. More than 70 houses were built, all within walking distance of the station. Advertisements issued by the Riverdale Park Company announced that the trip from Union Station on the B&O was 17 minutes, and the trolley ride from the Treasury Department was half an hour. A streetcar stopped in Riverdale every 10 minutes.

Many trolley-line companies formed independently over the years and in time merged, eventually becoming the DC Transit Company. The former Riverdale trolley station, still standing at 4701 Queensbury Road, became the popular Riverdale Bookshop in 1985. Today, the building is a memorial to Archie Edwards, a Piedmont blues icon, where blues workshops are held, along with weekly jam sessions.

On April 17, 1920, Gov. Albert C. Ritchie signed a law authorizing the residents of Riverdale to vote on articles of incorporation. The people so voted, and management by the Riverdale Park Company gave way to incorporation as a municipality. The town installed its first mayor, Samuel McMillan, and council in August 1920. As the Great Depression loomed, Riverdale was becoming a community that offered affordable housing within a convenient commute to Washington, DC.

In the late 1930s, the ERCO plant, near the town's northern boundary, produced an innovative all-aluminum plane, the Ercoupe. It was a safe, easy-to-fly aircraft, certified by the Civil Aeronautics Administration as "characteristically incapable of spinning." A total of 112 Ercoupes were produced in Riverdale before World War II. But by 1941, production at the plant was diverted to war-related materials, just months after the production of the airplanes was featured in the *Prince George's Post* as one of the county's most successful businesses.

The end of World War II brought great changes to Riverdale, as it did to most of America's small towns that bordered large metropolitan areas. Young families settled in the community in record numbers. The Calvert Homes Project, meant to temporarily house war workers at the ERCO plant, was given over to veterans attending the University of Maryland. Workers in the rapidly expanding federal government found Riverdale convenient to the District of Columbia. Government-secured loans to veterans with no down payment fostered development of empty parcels of land, and lots eligible for subdivision filled the demands of a booming real estate market.

Riverdale Park was also the home of notable artists, musicians, and poets. Juan Ramón Jiménez, a Nobel Laureate in literature, lived here and was a professor at the University of Maryland. Today, the language building at the University of Maryland is named in his honor. In the 1950s and 1960s, Riverdale Park was home to several notable pioneers of bluegrass music, including Don Reno, who is credited with inventing a preeminent banjo style that is a defining trait of the genre. Mandolin innovator Buzz Busby called Riverdale home, as did guitarist Bill Harrell, whose father was a Riverdale councilman, and Ed Ferris, of the Country Gentlemen. Gerald King moved to Riverdale in 1970 and began painting a vision of Riverdale. His works can be found throughout the town.

In 1949, Riversdale owner Abraham Walter Lafferty sold the mansion to the Maryland–National Capital Park and Planning Commission (M–NCPPC) for $28,000. It was used as the headquarters for the M–NCPPC for the next 16 years. It was then used as the headquarters for the Prince George's County delegation to the Maryland General Assembly until the early 1990s, when M–NCPPC, along with the Riversdale Historical Society, began restoration work.

In the late 1950s, with the aid of Gov. Theodore McKeldin, Mayor Claude Warren, the former manager of the Riverdale Park Company, worked with the Army Corps of Engineers to rechannel tributaries of the Anacostia to reduce dangerous flooding. This project created new parkland and opened space for new houses and even apartment buildings.

Today, the town's architecture is a mix of styles ranging from Victorian Queen Anne to mid-20th-century ramblers. The town center around the train station is still the focal point for community activities. The Riverdale Park Farm Market brings the community together weekly from April to November, and the MARC train transports commuters from a lovely train station rebuilt as a monument to the past to Baltimore or Washington, DC. A small, thriving business community surrounds the train area, supported by the Riverdale Park Business Association. Young families are moving back to the area, attracted by a core of residents who keep a vibrant community alive.

One

EARLY HISTORY

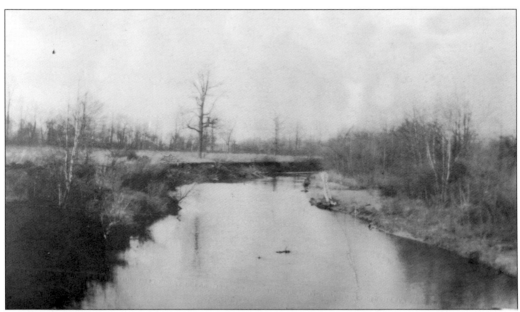

The geography underlying Riverdale Park is on a coastal plane that developed after the second Ice Age. With navigable waters, abundant fish and wildlife, and fertile soil, the area was ideal for human settlement. Archeologists have found evidence that Native Americans have lived in this region through the Paleo-Indian (11,000 BC–8000 BC), Archaic (8000 BC–1200 BC), and the Woodland (1200 BC–AD 1600) Periods. (PGCHS.)

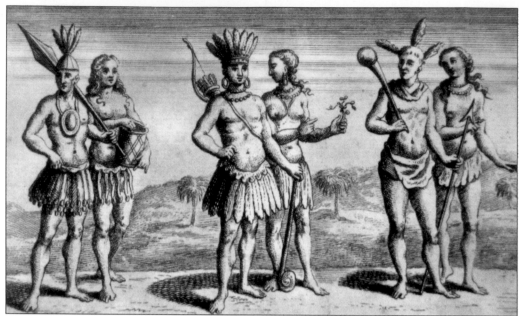

Above is a 1743 engraving by George Bickham showing Europeans' first encounter with Indians. The Algonquin Piscataway came to the region 10,000 years ago. Early Piscataway people were culturally similar to other Algonquin tribes in the mid-Atlantic region. Hunting and gathering, fishing, and subsistence farming were their means of survival. The invention of pottery enabled tribes to store food and increase planting. Consistent food supply brought villages together and led to population growth. From that, a more elaborate political structure developed. Trade between tribes became the cornerstone of the Piscataways' life. Below is a typical trade basket crafted and used by the Piscataway Indians, from a display at the Piscataway Indian Museum. (Above, M–NCPPC; below, PGCHS.)

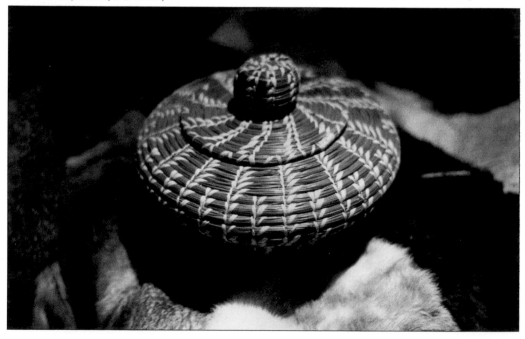

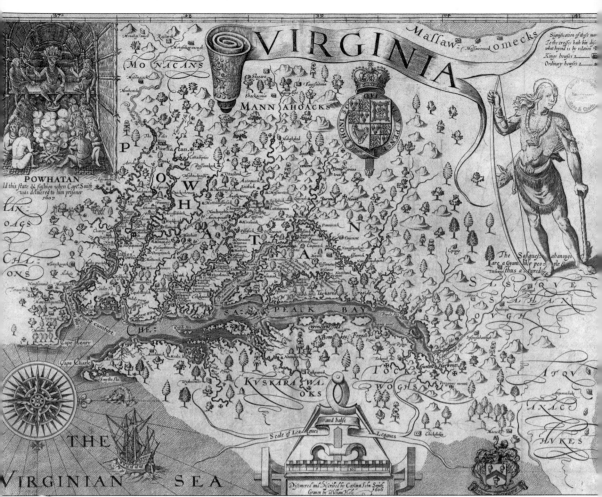

In the 16th and 17th centuries, the Spanish knew of the Chesapeake Bay, but Capt. John Smith was the first European to chart and do a thorough exploration of the Maryland region. Capt. John Smith recorded in his journals that he sailed up the Northeast Branch of the Potomac, known today as the Anacostia River, in 1608 in his search for the main stem of the Potomac River. He wrote, "Large and pleasant navigable rivers, heaven and earth never agreed better to frame a place for man's habitation." Captain Smith's mapping of the area was the greatest selling tool for early Maryland and Virginia colonization. Above is a map from Captain Smith's 1624 publication *The Generall Historie*. John Smith was not one for exaggeration. His writing about colonization was straightforward and stuck to the facts about the dangers and the possibilities of colonizing. Many other explorers made outlandish claims about an abundance of gold in the new world, but Captain Smith illustrated the monetary opportunities and what was actually possible. (LOC.)

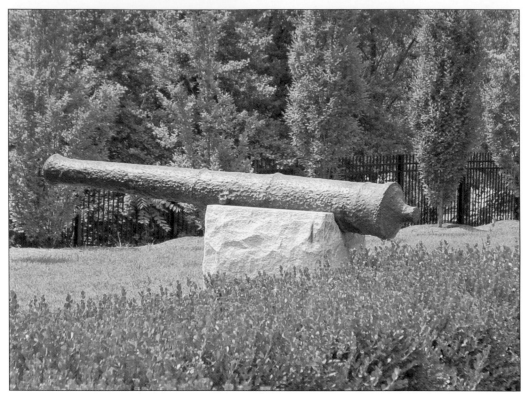

In 1634, when Leonard Calvert arrived on the shores of St. Clements Island with ships the *Ark* and the *Dove*, he brought with him this demi-culverin, now located at the Riversdale Mansion. It was presented to Charles Benedict Calvert in 1845. Preservation and restoration were funded by the Maryland Heritage Committee of Prince George's County in honor of the 350th anniversary of the state of Maryland. (HARP.)

**Projectile Point, Rhyolite
3000 B.C. – 300 B.C.**

The king of England required Lord Baltimore to pay a yearly fee of two Indian arrows and an amount of gold and silver. This display in the Riversdale Visitor Center shows an authentic arrowhead found on the Riversdale Mansion grounds. The display also contains two reproductions of the kind of arrows used by local Indians. (M–NCPPC.)

By the time Prince George's County was formed in 1696, the Piscataway had left the area. The land that encompasses present-day Riverdale Park was owned by descendants of the Scottish families brought to Maryland by Ninian Beall, who rose from indentured servant to representative in the House of Burgesses. He owned 7,000 acres of land in Prince George's County and was responsible for bringing 200 fellow Scotsmen to the county. (LOC.)

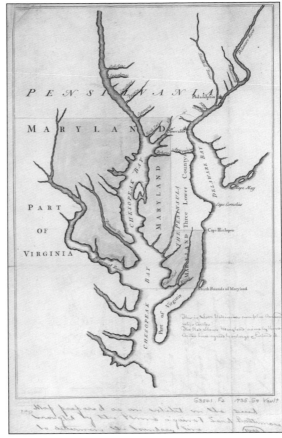

In 1794, Belgian aristocrat Henri Joseph Stier and his family fled from the French Revolution to the United States. His daughter Rosalie Eugenia Stier married George Calvert in 1799. With help and advice from George Calvert, Henri Stier purchased several parcels of land, amounting to 729 acres on the Northeast Branch of the Potomac that previously belonged to earlier Scottish settlers. It was there that he built Riversdale. (HARP.)

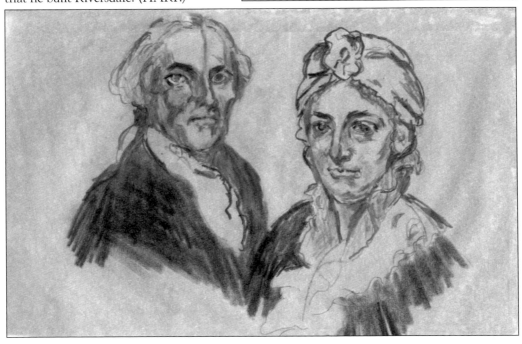

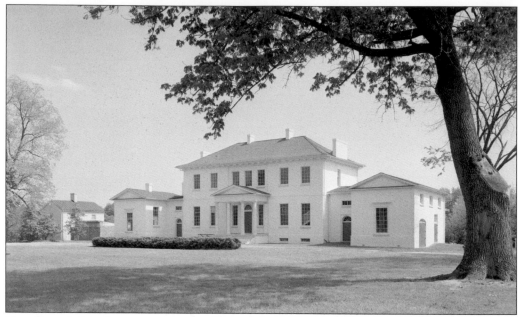

Henri Joseph Stier began constructing Riversdale in 1800. He and his wife occupied the finished east wing. By the summer of 1802, the political situation in Belgium had turned in favor of the aristocrats. Henri Joseph Stier decided to return to his homeland with his family in 1803, leaving George and Rosalie Calvert to live in and complete Riversdale. (LOC.)

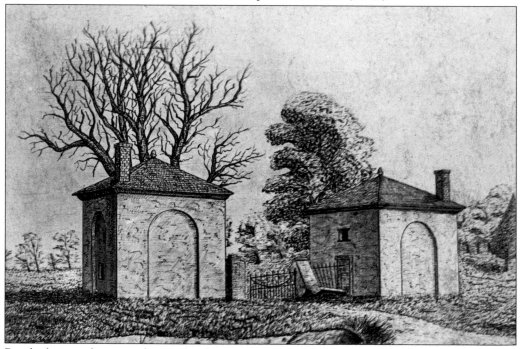

Besides being a farmer and major landowner, George Calvert was involved in several businesses. He served as the president of the Bank of Washington in 1809, and in 1813, he became the director of the newly formed Baltimore-Washington Turnpike Company. These gates once stood at the entrance to Riversdale on the Baltimore-Washington Turnpike. (PGCHS.)

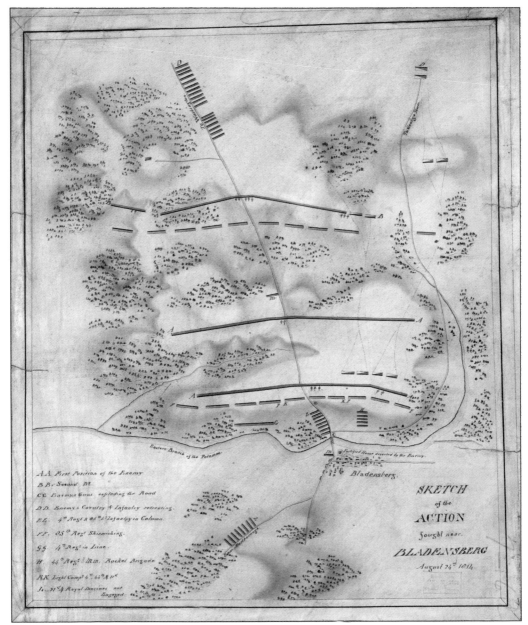

SKETCH

of the

ACTION

fought near

BLADENSBERG

August 24.th 1814.

On August 24, 1814, the Battle of Bladensburg took place. Although the Battle of Bladensburg was close enough to Riversdale for Rosalie Calvert to watch from her backyard, the estate remained virtually unharmed by the War of 1812. The British defeated the American troops at Bladensburg. These troops consisted primarily of an ill-trained, hastily assembled militia of local merchants and farmers. British troops had recently returned from fighting the Napoleonic Wars, were armed with Congreve rockets, and were battle-ready. Commodore Joshua Barney put up a valiant fight in the Chesapeake Bay, but was unable to defeat the war-hardened British troops. President Madison watched from a local hilltop as the American troops were forced to retreat from the might of the British forces, who then marched into Washington, burning what are known today as the old north wing and the old south wing of the Capitol as well as the White House. (LOC.)

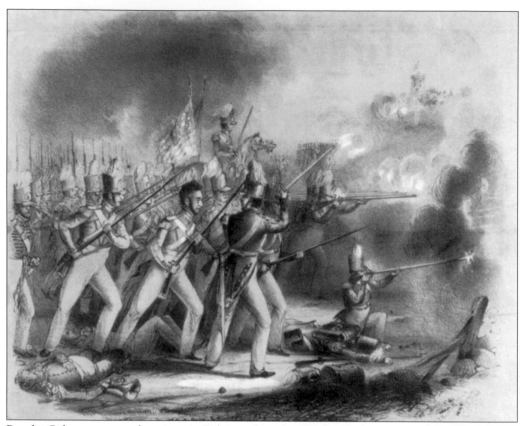

Rosalie Calvert wrote to her sister in Belgium about her firsthand observance of the War of 1812, claiming to have seen "cannonballs with my own eyes." This would be virtually impossible. What she probably saw were the fiery Congreve rockets the British used to defeat the Americans. (LOC.)

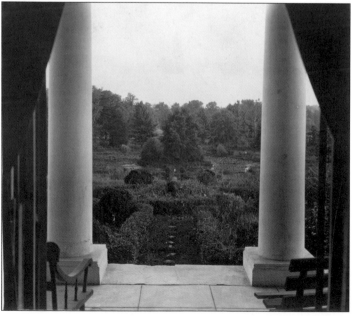

The eldest Calvert son, George Henry, was spared from being enlisted in the conflict by being away at school in Philadelphia. In his autobiography, he wrote that his father and his field hands went down to Bladensburg after the fighting to help bury the dead and administer aid to the wounded. The family observed the battle from this backyard vantage point. (M–NCPPC.)

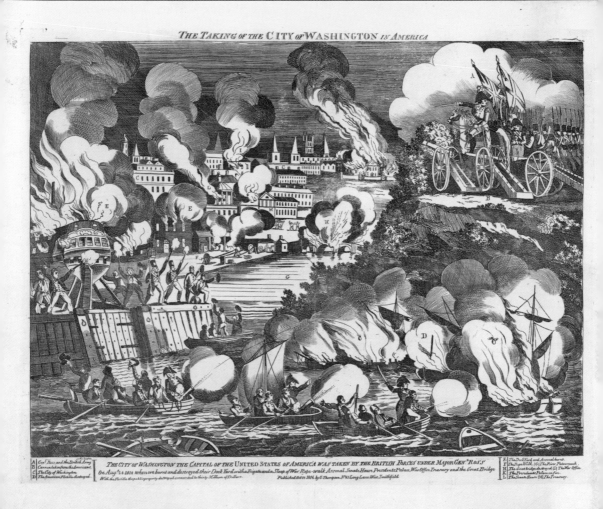

The Battle of Bladensburg became known as the "Bladensburg Races." It was a definitive win by British troops and a black eye for America. Soon after this event, on September 12, 1814, British troops attacked Baltimore. This time, the situation was very different from the one in Bladensburg a few weeks earlier. The Americans were better prepared and more organized and, consequently, fought more efficiently than they had a few weeks earlier. During the advance on Baltimore, British general Robert Ross was killed and his command taken over by Col. Arthur Brooke, who launched a naval bombardment of Fort McHenry. By September 14, the British fleet retreated from Baltimore. This was the last battle to take place before the signing of the Treaty of Ghent and the official end of the war. Because of slow communication, the Battle of New Orleans was still to come. Lyrics for the US national anthem, "Star-Spangled Banner," come from "Defense of Fort McHenry," a poem written in 1814 by the lawyer and poet Francis Scott Key after witnessing the bombardment of Fort McHenry. Shown above is a wood engraving published by G. Thompson on October 14, 1814. (LOC.)

Rosalie Calvert suffered from failing health in the years following the War of 1812. For many years, she had long bouts of typhoid fever, and she was never able to regain her full strength. She bore the grief of four of her nine children dying at young ages. She died on March 13, 1821, at age 43, from congestive heart failure. (HARP.)

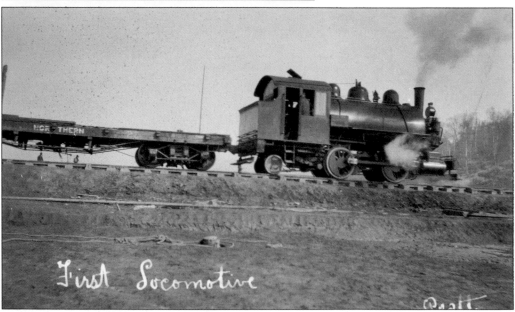

By 1828, George Calvert was the wealthiest man in Prince George's County. In the remaining decade of his life, with the aid of his son Charles Benedict, Riversdale continued to develop. A significant advance came in 1832, when the B&O Railroad track from Baltimore to the capital was laid through Riversdale. This expansion took place after a protracted federal debate over the railroad's pernicious effect on Washington's natural beauty. (LOC.)

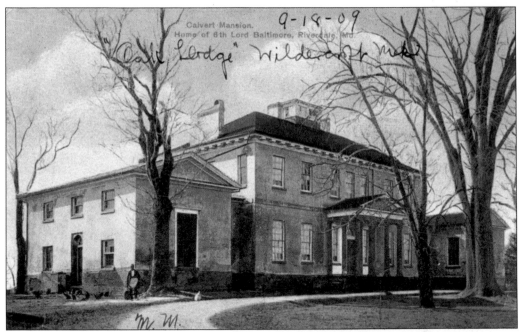

George Calvert died in 1838. He left a will that divided his estate among his three children. At the time of his death, his affairs were complex. It took eight years to settle all disputes. Charles Benedict Calvert bought out his siblings' share of Riversdale. The family properties included Rossborough Farm and the Avalon mill in Bladensburg. (TRP.)

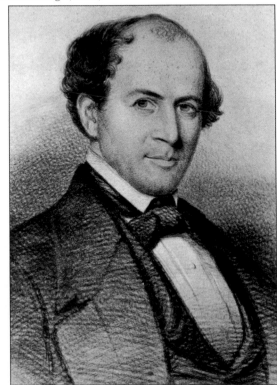

Charles Benedict Calvert was a US congressman from Maryland's 6th Congressional District. In 1860, Calvert was elected as a Unionist to the 37th Congress, serving from March 4, 1861, until March 3, 1863. Though Calvert was a Unionist, he was known in Congress as a proponent of slave owners' property rights and beneficiary of the planters' way of life. (M–NCPPC.)

CINDERELLA.

The property of C. B. Calvert, Esq. of Riversdale, Prince George's co. Md.

Charles Benedict Calvert was an innovative and scientific farmer, keenly interested in progressive, modern farming techniques. He was the president of the Prince George's County Agricultural Society and the first president of the Maryland State Agricultural Society, and he helped found the US Agricultural Society and served as vice president. In 1863, as a congressman, he sponsored legislation that created the US Department of Agriculture. On the Riversdale property, he constructed a unique octagonal barn. Octagonal-shaped buildings were considered to have properties conducive to good health and spiritual well being. This structure made it possible to house several kinds of farm animal in one building. The building was located on the corner of Riverdale and Taylor Roads. It burned in 1904. (Above, M–NCPPC; below, LOC.)

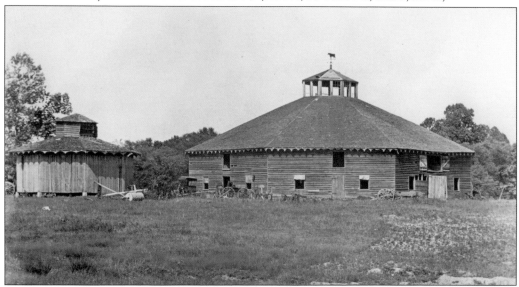

The Rossborough Inn, indicated on this map, was built between 1798 and 1812 as a rest stop between Baltimore and Washington, DC, by speculator John Ross. After it failed as an inn, George Calvert purchased it to be part of the Riversdale estate. In 1858, his sons Charles Benedict and George H. Calvert shared ownership of the property. They donated the 428-acre Rossborough for the development of the Maryland Agricultural College campus. Charles Benedict Calvert served as the first president of its board of regents and is considered the father of the University of Maryland. In April 1864, Gen. Ambrose E. Burnside and 6,000 soldiers of the Union's IXth Army Corps camped on the Maryland Agriculture College campus en route to Virginia. Later that summer, Confederate general Bradley T. Johnson used Rossborough as his headquarters while preparing to take part in a raid against Washington. (LOC.)

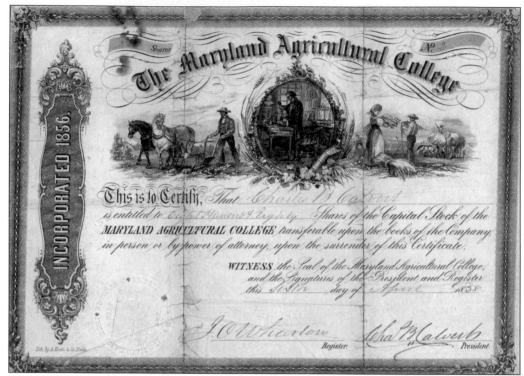

This original stock certificate issued for the Maryland agricultural college entitles Charles Benedict Calvert to 880 shares of stock in the institution. It is signed by Calvert, acting as president of the institution as well. (University Album, Special Collections, University of Maryland Libraries.)

In July 1862, President Lincoln signed the Morrill Land Grant Act. This legislation awarded federal funds to schools that taught agriculture or engineering or provided military training. In February 1864, the Maryland Agricultural College became a land-grant college following the Maryland Legislature's vote to approve the Morrill Act. (LOC.)

Charles Benedict Calvert was a champion of the single-wire telegraph. In 1843, after several years of lobbying the government for funding, his friends Samuel Morse and Alfred Vail persuaded Congress to appropriate $30,000 for construction of an experimental, 38-mile telegraph line between Washington, DC, and Baltimore, Maryland. On April 9, 1844, Morse and Vail successfully tested their device, transmitting a message from the Capitol building to Riversdale. An impressive display followed on May 1, when news of Henry Clay's nomination for president was telegraphed from Baltimore to the Capitol building. This event preceded the Morse's best-known message, "What hath God wrought," sent along telegraph lines that ran above the B&O Railroad line through Riversdale. The single-wire telegraph advanced from this small invention to a network throughout the United States in a few short years. (Both, LOC.)

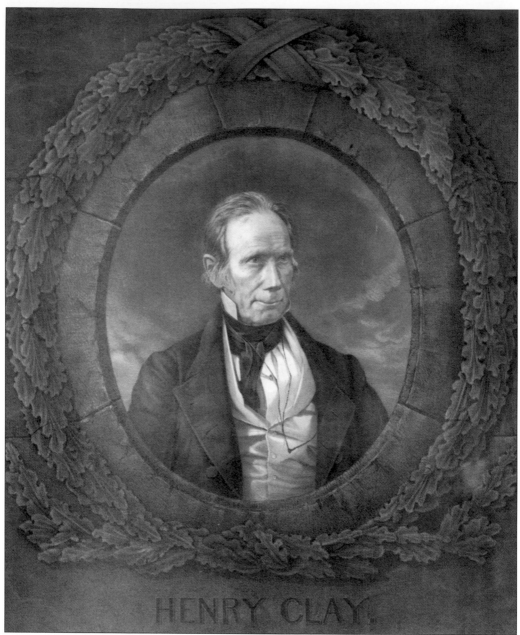

HENRY CLAY.

Henry Clay, known as the "Great Compromiser," at different times represented Kentucky in both the US Senate and the House of Representatives. He was an influential political figure during the mid-19th century, intrinsically involved in shaping the nation's history. He was known for his outstanding oratory prowess. Henry Clay was a frequent guest at Riversdale. It is speculated that Clay wrote most of the Compromise of 1850 while staying with his close friend and political ally Charles Benedict Calvert at Riversdale. The Compromise of 1850 consisted of five bills that passed in September of 1850, defusing a confrontation between the slave states and free states and delaying secession and civil war for another decade. Clay was such a frequent guest at Riversdale that the guest room he used was dubbed the "Clay Bedroom." Clay and Charles Benedict Calvert shared political views. (LOC.)

Although Lincoln originally made an agreement with Maryland allowing plantation owners to retain their slaves as long as they remained in the Union, the situation changed radically over the course of the Civil War. After the Emancipation Proclamation, border states like Maryland found a serious problem when members of their enslaved labor force ran away to freedom, leaving the fields to go fallow. (HARP.)

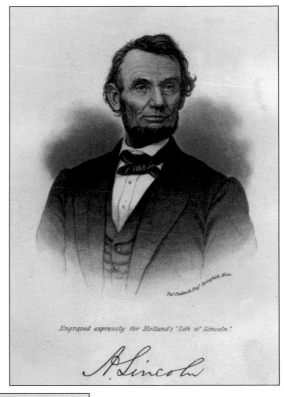

Engraved expressly for Holland's "Life of Lincoln."

Abraham Lincoln received only one vote from Prince George's County in the election of 1860; nevertheless, he was willing to work with the local politicians to preserve the Union. As a Congressional representative for southern Maryland, George Calvert's primary concern was the interest of the plantation owners in Prince George's County. Runaway slaves were a considerable concern to the men Calvert represented. He communicated with Abraham Lincoln regarding this issue. (LOC.)

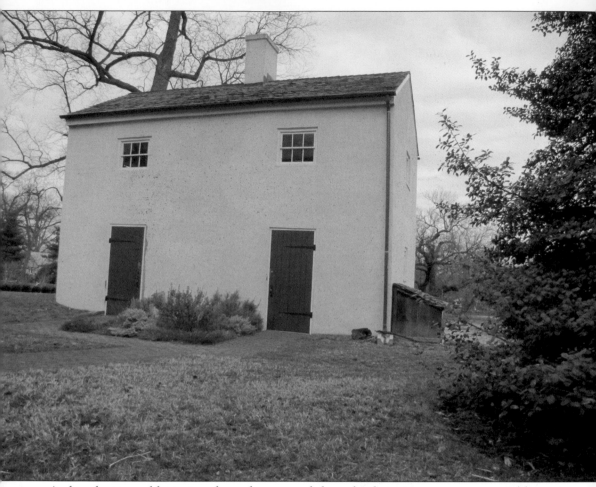

Archaeologists and historians have documented that a kitchen, servant quarters, washhouse, smokehouse, privy, and garden once stood in the yard east of the Riversdale Mansion. Today, only one of the Riversdale Dependency buildings is still standing. The remaining outbuilding left on the site of the original Riversdale Plantation was probably erected during the lifetime of Charles Benedict Calvert, though archeological surveys have indicated that another such structure probably existed on this site when Rosalie and George Calvert were living at Riversdale. The house is made of simple brick and covered with stucco, like Riversdale. It is located 30 feet from the main house. Today, it is used as part of the house museum and contains a Colonial kitchen. The building contains exhibits that interpret Colonial food preparation and the lives of Adam Francis Plummer and other slaves who lived at Riversdale. (HARP.)

Adam Francis Plummer was born into slavery at Goodwood Plantation in 1819. Plummer had the ability to read and write, which was unusual for someone who was a slave at that time. He also was both a carpenter and a shoemaker. He moved with the Calverts to Riversdale in 1829. He lived and worked at Riversdale until 1870, six years after the Emancipation Proclamation was issued by Abraham Lincoln. (M–NCPPC.)

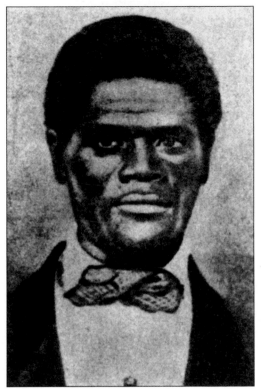

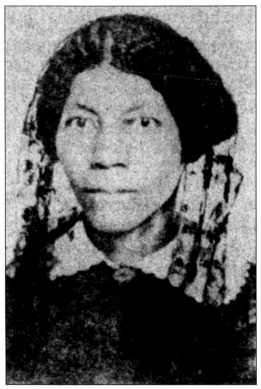

Emily Sanders was a slave at a plantation located in Lanham called Three Sisters. She was the wife of Adam Francis Plummer. Adam and Emily were married at the New York Avenue Presbyterian Church in Washington, DC. Their marriage was considered legal, and they received a license. Most slave marriages at that time took place on a plantation and were not legally binding. (M–NCPPC.)

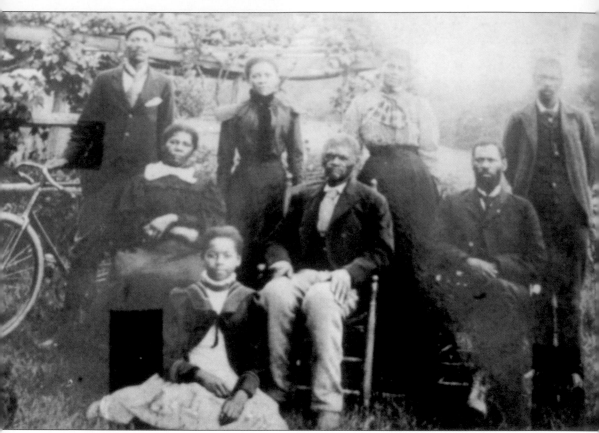

Slavery divided the Plummer family. Adam lived at Riversdale, and Emily and their children were sold to several different plantations in Maryland and Washington, DC. Adam visited his family when he could. He taught his children to read and write. The Plummers had nine children: Sarah Miranda, Henry Vinton, Elias Cupid Quincy, Julia Ann Caroline Maria, Nicholas Saunders, Marjorie Ellen Rose, Margaret Jane, Robert Francis, and Nellie Arnold. Emily struggled to keep her children together. Daughter Sarah Miranda Plummer was sold down South, ending up in New Orleans. Following the issuance of the Emancipation Proclamation, Emily attempted to escape with her children and reach Adam at Riversdale. They were arrested as fugitive slaves and imprisoned in Baltimore. Ultimately, the family was released into Adam Francis Plummer's custody. The eldest son, Henry, joined the US Navy. Following the war, Henry found sister Sarah in New Orleans and reunited her with the family. In 1870, Adam purchased 10 acres of land behind Riversdale and built Mount Rose, the family home. Emily died in 1876, and Adam died in 1905. (M–NCPPC.)

Henry Vinton Plummer was honorably discharged from the Navy in 1865. He attended Wayland Seminary in Washington, DC, graduating as a Baptist pastor. In 1884, Plummer was appointed chaplain of the 9th Cavalry by Pres. Chester A. Arthur. He was dismissed from the Army on a trumped-up charge. In 2004, Maryland governor Robert Ehrlich saw that the court martial of Henry Plummer was overturned, returning him to his rightful status as an American hero. (M–NCPPC.)

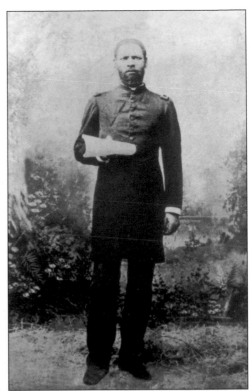

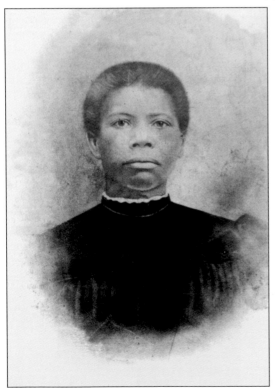

Sarah Miranda Plummer returned to Maryland, where she began a revival, converting several family members and friends to the Baptist faith. After a year, she established the First St. Paul Baptist Church in Bladensburg, Maryland. The church, which now stands in Capitol Heights, is still thriving and is as a testament to the faith of the family. (M–NCPPC.)

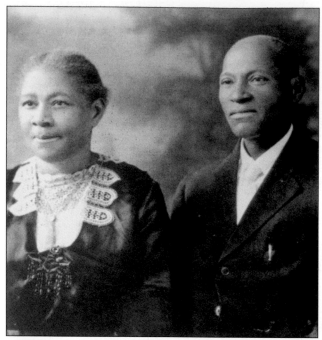

Nellie Arnold Plummer and Robert Francis Plummer, fraternal twins and the youngest of Adam's and Emily's children, preserved the family history through their father's diary. Nellie was the author of the self-published *Out of the Depths or the Triumph of the Cross*, a story about the Plummer family's struggle under slavery. She was the first female student to attend the Normal Department of Wayland Seminary in Washington, DC, from 1875 to 1878. She worked over 45 years as a teacher in Forestville, Maryland, and Washington, DC. Robert Francis Plummer was a professional pharmacist. Below is a photograph of brother Nicolas Plummer (seated at right) and his family at Rose Hill. (Both, M–NCPPC.)

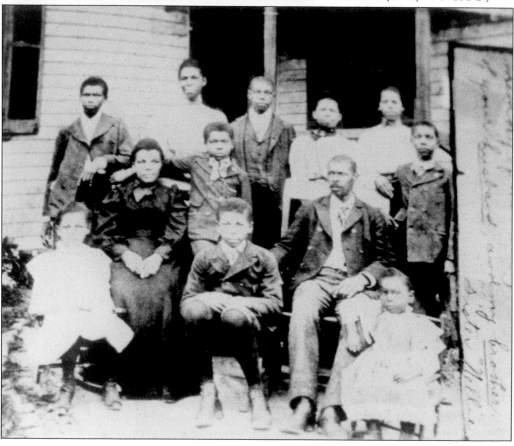

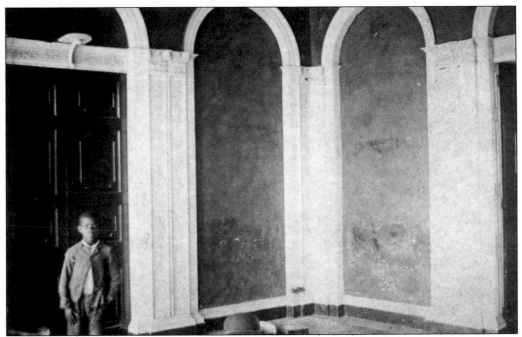

Following the death of Charles Benedict Calvert, his wife, Charlotte Augusta Norris Calvert, went into a decline and spent her remaining years living with one of her sons in Baltimore. Charles Benedict Calvert's will stipulated that the property of Riversdale be divided among his five surviving children and wife. Over the next 10 years, the property and the mansion that had been the life of Charles Benedict Calvert went into a decline from neglect. Following Charlotte Calvert's death in 1876, the contents of Riversdale were sold at auction. The mansion stayed in the Calvert family until 1887. (Both, M–NCPPC.)

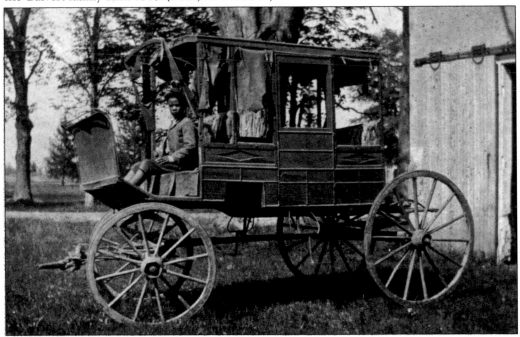

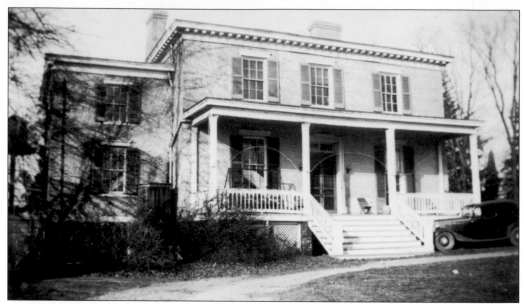

Around 1860, Charles Benedict Calvert's second son, Charles Baltimore Calvert, built a home on his portion of Riversdale, in an area located between Rossborough Farm and the Riversdale Mansion, and named it McAlpine. This site is currently referred to as the Cafritz property. According to local legend, this interesting site may have been the location of Indian burial grounds and several slave dwellings. (PGCHS.)

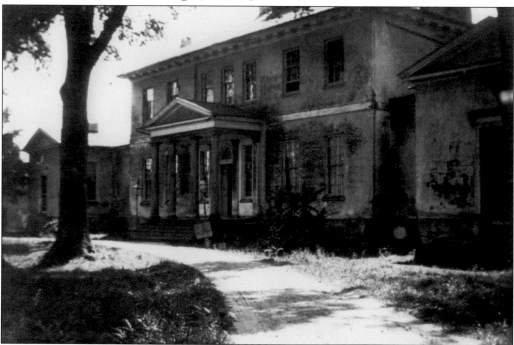

Charles Baltimore continued to live in McAlpine after 475 acres and the Riversdale Mansion were sold to a real estate syndicate from New York. Businessmen John Fox and Alexander Lutz took control for a total purchase price of $47,000. Fox took several mantle pieces, chandeliers, and furnishings from Riversdale and had them installed in his home in New York. (M–NCPPC.)

Two

THE RIVERDALE
PARK COMPANY

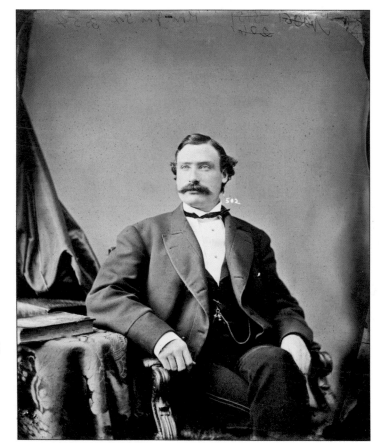

John Fox, shown here in a Mathew Brady portrait, was born on June 30, 1835, and died on January 17, 1914. He served New York as senator from 1874 to 1878 and president of the National Democratic Club from 1894 to 1910. He was as an iron merchant and real estate speculator. He and business partner Alexander Lutz purchased 475 acres of Riversdale from the Calvert family in 1887. They planned a modern railroad suburb similar to Riverdale, New York. (LOC.)

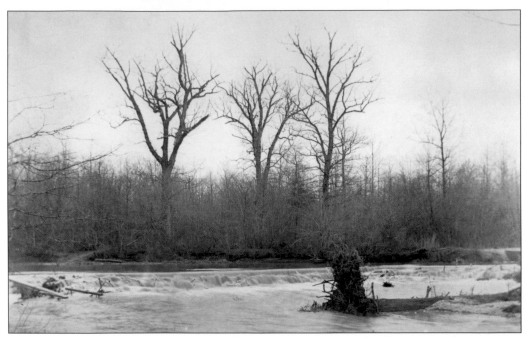

The Riverdale Park Company arranged elaborate advertising and selling events, bringing out trainloads of potential buyers to experience the new town. Advertisement of the day emphasizes the great natural beauty of the Northeast Branch of the Potomac, juxtaposed with the modern convenience of commuting to Washington, DC, by train and trolley. The Riverdale Park Company also built a modern railroad station on a guaranteed reimbursement by the B&O railroad when 70 homes were erected in Riverdale Park. The train station was then, as it is today, located in the town center. Pictured below is one of the many events held at Riversdale. (Both, M–NCPPC.)

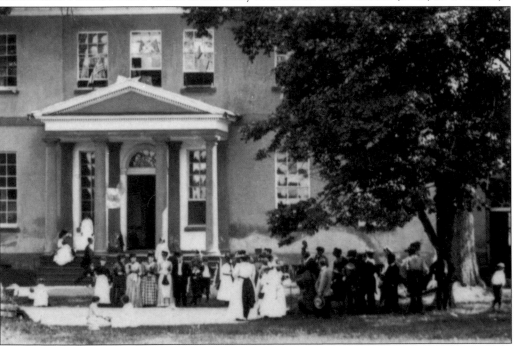

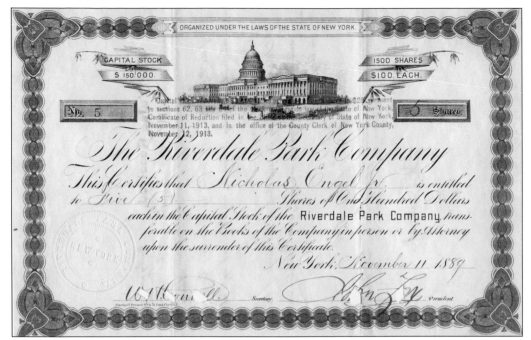

This is an original stock certificate issued from the Riverdale Park Company, number five, signed by John Fox. Five shares of stock were required per purchase. Each share was $100. The Riverdale Park Company immediately began populating the new subdivision with model homes to attract potential buyers. (TRP.)

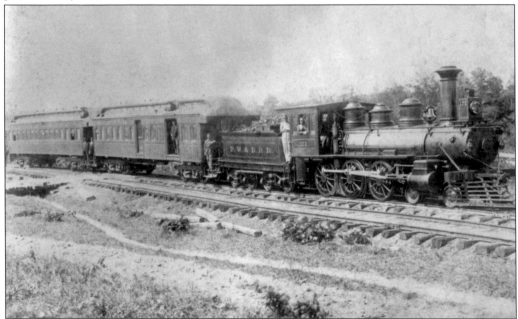

The Calvert family originally allowed the B&O Railroad to travel through Riversdale on the agreement that there would always be a train stop on the property. That made the new town of Riverdale Park an ideal location for a government-employee commuter suburb to develop. Riverdale Park became one of the earliest commuter suburbs in Prince George's County. (PGCHS.)

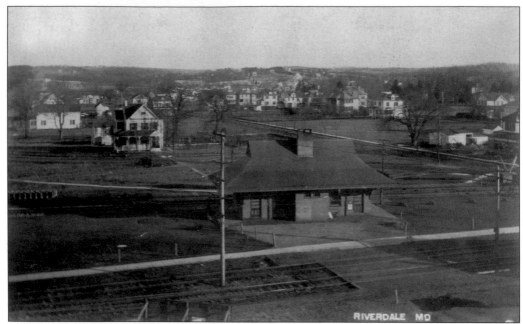

The railway station was built in 1890 by the Riverdale Park Company. This train station was the pride of Riverdale Park and stood on the Lafayette Avenue side of the track. The original frame building was largely unused after the World War II and eventually closed, left to be destroyed by the elements. (TRP.)

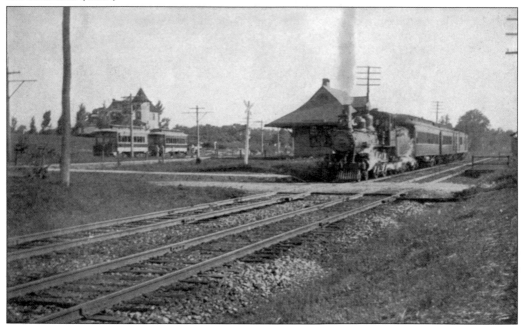

The trolley line arrived by the early 1900s. Today, the original line can be traced by the telephone poles that go through town center and beyond the East-West Highway overpass to College Park. Today, the former trolley route is being developed into the intercounty Rhode Island Trolley Bike Trail by the M–NCPPC. This is a picture of the Riverdale Park town center in 1909. (M–NCPPC.)

The B&O Royal Blue Line was noted for its luxury, elegant appearance, and speed. These photographs show a typical interior of a B&O commuter train and the bar car. The Royal Blue Line was the B&O Railroad's foremost commuter passenger train operating between New York City and Washington, DC, starting in 1890. The B&O Railroad line featured well-appointed passenger cars with interiors paneled in mahogany, enclosed vestibules, heating and lighting, and elegant leaded-glass windows. The exterior of the train was painted a dark royal blue detailed with gold-leaf trim. From the late 1890s to World War I, the B&O operated six daily Royal Blue trains. (Both, LOC.)

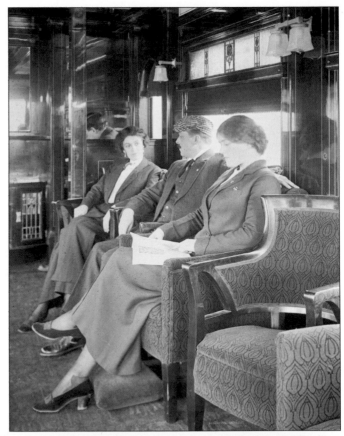

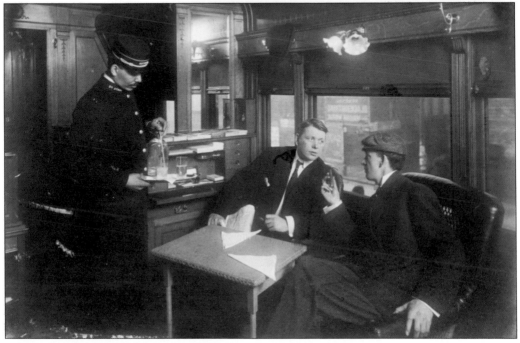

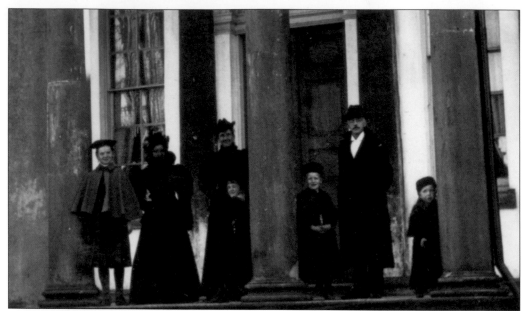

In 1912, Washington-area developer Thomas H. Pickford purchased Riversdale at a public auction. With the help of his brother, who was a builder, he spent over a year restoring the Riversdale Mansion with the intent of making it his family's home. After the remodeling was complete, Pickford's wife was not interested in living in Riversdale. While Pickford attempted to find a buyer or long-term renter, he had an arrangement with A.H. Lofstrand to operate Riversdale as the Lord Baltimore Club, a country club, at the location. The Lord Baltimore Club failed after a brief period of operation. Below is an interior picture of Riversdale during that time period. (Both, M–NCPPC.)

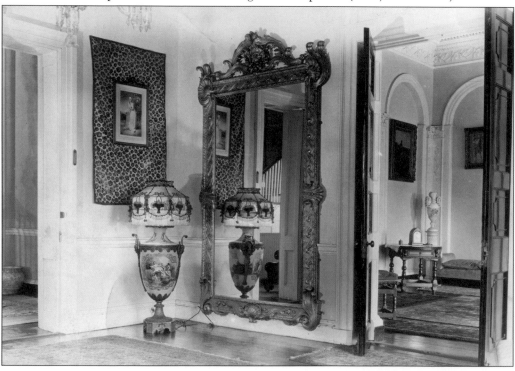

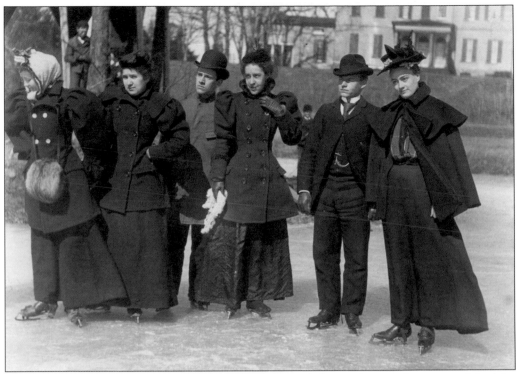

The man-made lake behind the Riversdale Mansion and the pavilion in the center of the lake were utilized by many residents of the town for recreational purposes. It served as an ideal place for ice-skating in the winter months of 1918, when the Washington area suffered one of its record-breaking cold spells. The sport was very popular that winter, and the newspapers from that time were full of articles about the recreational possibilities of eight inches of ice covering the Potomac River. The young people in Riverdale Park had an opportunity to pursue this form of recreation on much more civilized territory. The smart little octagonal building on the man-made island in the center of the lake was a refuge and a destination for boaters, nature-lovers, and painters. (Both, M–NCPPC.)

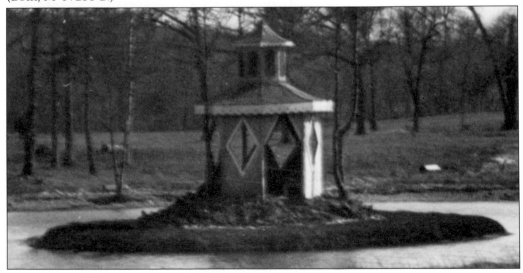

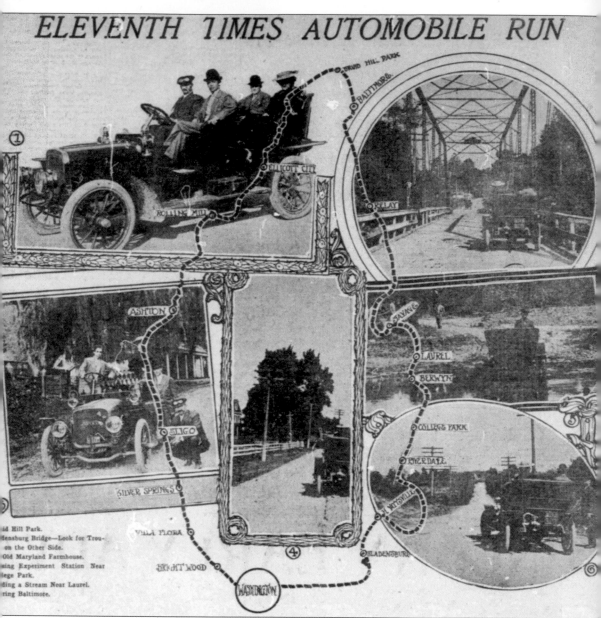

This newspaper article is titled, "Frequent Difficulties Experienced En Route to Monumental City." "Just a bit of advice: If you want to go to Baltimore Take a Baltimore and Ohio or a Pennsylvania train, but leave 'The Rocky Road to Dublin' severely alone. There may be worse roads in the world than the one running between Washington and Baltimore, but they have not yet been discovered by automobilists." The eleventh automobile trip made by the *Times* representative was from Washington to Baltimore on October 2 1907. In 1907, Baltimore Boulevard was the main link between Washington and Baltimore. The condition of the road was spotty at best. This account of what an adventure it was to travel from one city to the other seems like a step backward in mode of transportation. Washington Boulevard was rutted, muddy, and full of sharp rocks. At Riverdale, it was noted that the road was free after the train tracks and was still rutted but free between Riverdale Park and College Park. (LOC.)

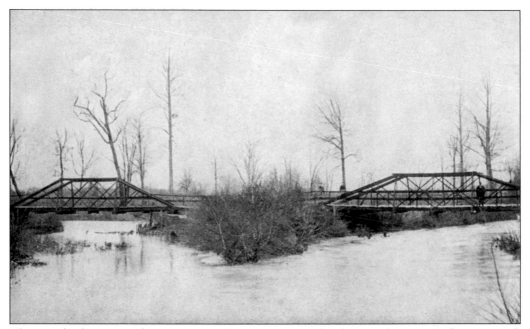

The twin bridges were a longtime symbol of Riverdale Park. They can be seen on the town seal. The bridges spanned the Eastern Branch of the Potomac, which divided Riverdale Park from east to west. The need for two bridges was eliminated when the Army Corps of Engineers rechanneled the Anacostia River in the late 1950s. (M–NCPPC.)

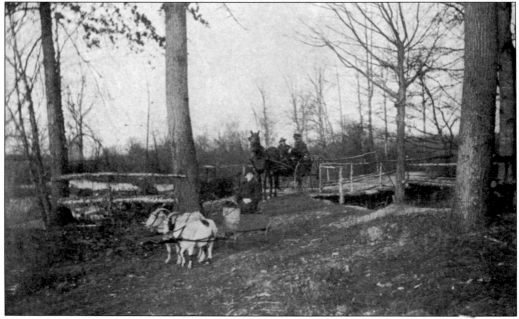

This picture depicts a goat cart traveling over one of the many bridges that crisscrossed the natural tributaries running throughout Riverdale Park. Many residences kept small livestock, such as chickens, goats, and horses. Unlike Hyattsville, which, even by the early 1900s, had started developing an urban character, Riverdale Park maintained the quality of a bucolic country village. (M–NCPPC.)

By the early 1900s, young families began choosing Riverdale Park for their permanent home. It was an ideal environment to have their children grow up in. It offered the best of both worlds: country life for the wife and children and an easy commute for the father to his employment in Washington, DC. (TRP.)

This picture shows the quality of life that Riverdale Park offered a young family. The Riverdale Park Company advertised inexpensive quality homes and large lots. Judging from the picture, taken in about 1910, the Riverdale Park Company delivered what it promised. Though the streets were not paved, town manager Joseph Blundon owned a concrete factory and provided the town with an extensive sidewalk system. (TRP.)

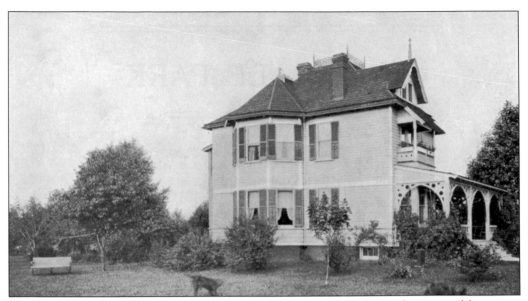

This is a picture of Capt. G.H. Read's home. The unique porch was used on several houses in Riverdale Park, immortalized in the 1970s mural that stood on the corner of East-West Highway and Baltimore Avenue. The architectural style is Queen Anne. It became fashionable in the 1880s and 1890s, when the Industrial Revolution brought new technologies and builders started to use mass-produced, precut architectural trim. (M–NCPPC.)

This is a photograph of Capt. G.H. Read's garden, located on the grounds of his home, which is featured in the photographs above. This photograph shows exactly what five shares of stock amounted to, as far as land goes. The Read property had an English-style garden, including a fruit orchard adjacent to the home. (M–NCPPC.)

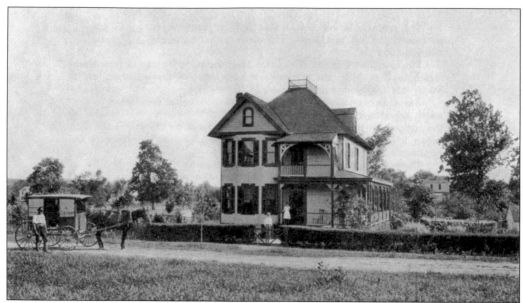

This house, known as the Burrhus House, is still standing today and is located on Ravenswood Road. Many residents had a house in Riverdale Park that they used as a summer home. The Burrhus family lived year-round in Riverdale Park. In the left corner of the picture, the Farris Dairy truck is visible as it delivers fresh milk. The Burrhuses were one of the truck's daily stops. (M–NCPPC.)

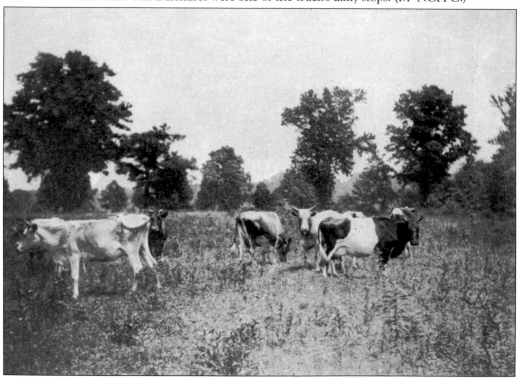

Riverdale Park's Farris Dairy supplied the residents of the town with fresh milk, butter, and cheese. Often, Mrs. Farris and her son would make the milk-run delivery to the town's residents from the horse-drawn wagon. (M–NCPPC.)

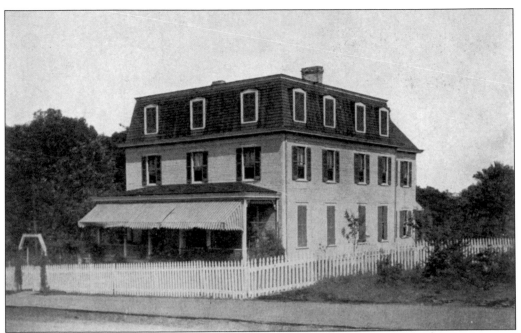

This house is listed as originally belonging to William B. Severe. He was one of the more influential residents of early Riverdale Park, involved in several citizen-action groups and a member of the Masonic lodge. This house, with its characteristic mansard roof, can be recognized today as the Chambers Funeral Home, located on Cleveland Avenue in Riverdale Park. (M–NCPPC.)

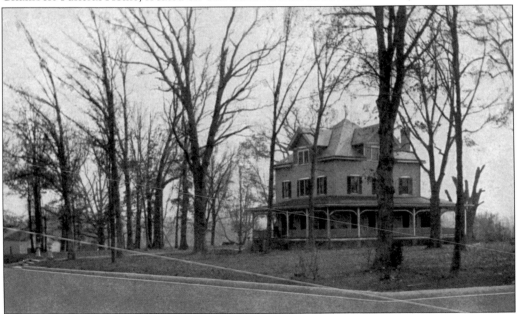

Oak Villa, shown above, was located on Oliver Street next to the railroad tracks. It was home of Joseph A. Blundon, first manager of the Riverdale Park Company and considered the father of Riverdale Park. Tragically, his 13-year-old son and two friends lost their lives on the tracks near Blundon's home in 1895. Fourteen years later, Joseph Blundon suffered the same fate at the same location. (M–NCPPC.)

This Cotswold Cottage–style house is listed as the residence of George Seahorne. The house had an outbuilding that Seahorne, like many Riverdale Park residents, probably used for raising chickens or keeping a horse and wagon. Note the diamond-shaped windows and three window sets, characteristic features in many early Riverdale Park homes. (M–NCPPC.)

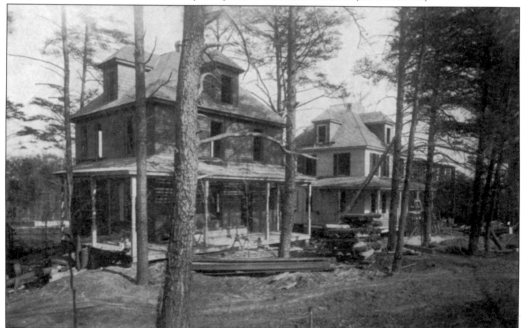

This picture depicts houses being constructed by builder Walter R. Wilson, who was the most preeminent builder in Riverdale Park and Hyattsville. His career as a builder spanned from the 1890s to the late 1930s. He was known for his large four-square frame house construction. (M–NCPPC.)

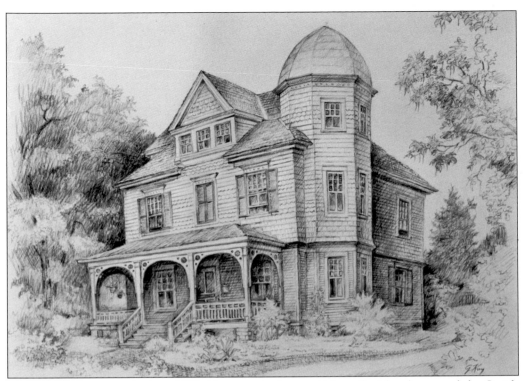

The Smith House was built in 1895. This was the home of Harry Smith, who owned the Smith Gravel Company in Beltsville and later was president the Citizens Bank of Riverdale. This exceptional example of Queen Anne–style architecture is in the National Register of Historic Places and has plans registered in the Library of Congress. (Gerald King.)

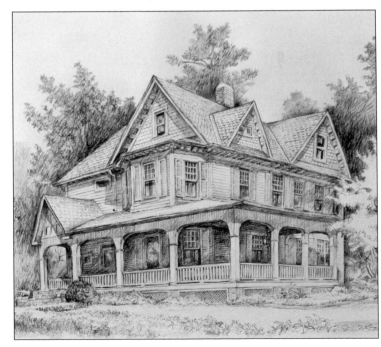

The Warren House, located on Oliver Street, was the home of Claude E. Warren. He was the longtime manager of the Riverdale Park Company and the son-in-law of Joseph E. Blundon, the first manager of the Riverdale Park Company. The Warren House is an excellent example of the Queen Anne style of architecture. It is a smaller version of a house located in Hyattsville. (Gerald King.)

This was originally the home of H.T. Knight. His son "Piggie" Knight is documented in a well-known memoir by James H. Baines. The Knights lived in a four-by-four-style house with a wide wraparound porch that was popular at the turn of the century. (M–NCPPC.)

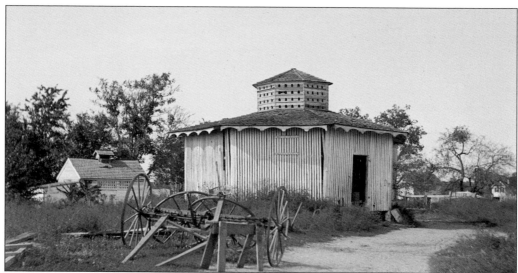

The original octagonal barn belonging to Charles Benedict Calvert remained standing and was used by the Riverdale Park Company to store building supplies. Once the pride of Riversdale, it had deteriorated badly over the years. Formerly housing a brickyard, blacksmith shop, and barn yard, it burned to the ground in 1902. Today, Riverdale Elementary School stands on its former location. (LOC.)

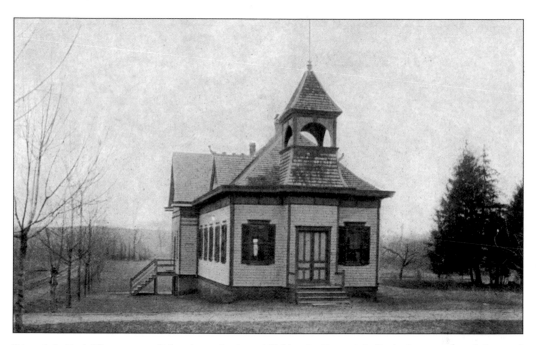

Riverdale Park Elementary School was built in 1895 by the Riverdale Park Company and donated to the county in exchange for supplying teacher Mrs. John L. McGee. The school was located on Riverdale Road in front of the Riversdale Mansion. The building was 28 by 60 feet with 12 windows and a belfry. The lower picture from the early 1900s shows an early class of students who attended Riverdale Park Elementary School. It includes the children of all the initial residents of Riverdale Park. A marker has been placed at the spot where the school was once located. (Both, M–NCPPC.)

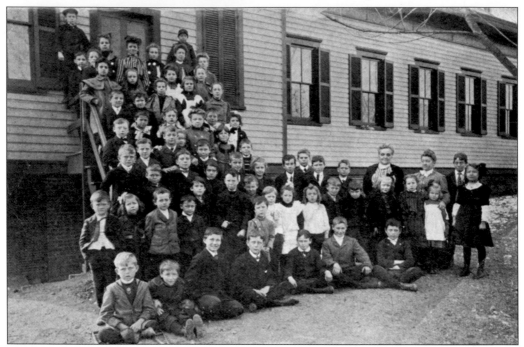

The Riverdale Park Elementary School class of 1906–1907 is pictured. As the community grew, the original schoolhouse became limited in space and required expansion. By 1899, the Riverdale Park Elementary School student body had outgrown the school. The house on the corner of Riverdale Road and Taylor Road was purchased for use as a school annex. That house is still standing and is now a private residence. (M–NCPPC.)

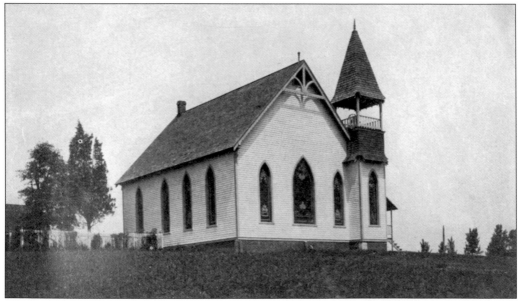

The Riverdale Presbyterian Church was located on the hill next to the Calvert family cemetery. In this picture, it is located to the left of the church. It was standing until East-West Highway was constructed. The active congregation move to a new site in University Park in the 1950s. (M–NCPPC.)

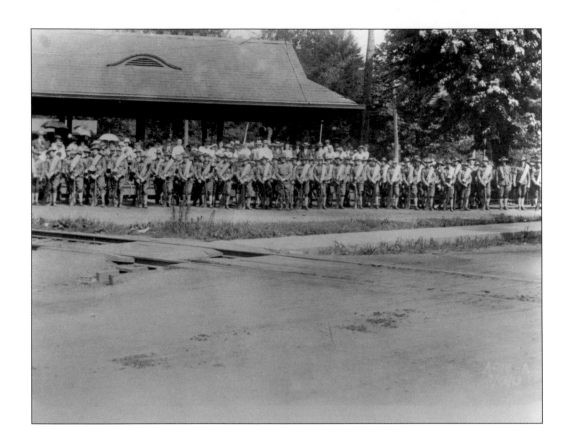

Company F, 1st Infantry Regiment, Maryland National Guard was organized in 1912 with 56 men in its first muster roll. Men from Riverdale Park, College Park, and Hyattsville participated in maneuvers locally until 1916. They were then assigned to Gen. John "Black Jack" Pershing to combat Mexican bandit José Doroteo Arango Arámbula, better known as "Francisco Villa," or "Pancho Villa," on the Texas-Mexico border. The Maryland regiment saw very little action but still received a hero's welcome home. Within a year of returning from this altercation, the Maryland National Guard was called upon to serve with General Pershing in World War I, joining British and French forces on the Western Front against Germany. The Maryland National Guard unit became part of the 115th Infantry, 29th Division, known as the "Blue and Gray," comprising men from both sides of the Mason-Dixon Line. (Above, Maryland Historical Society; below, LOC.)

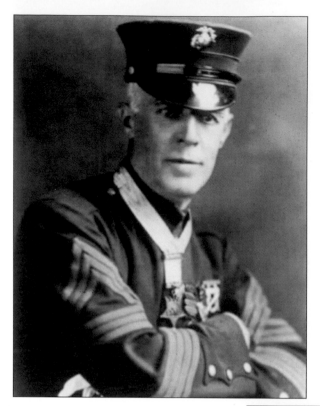

Henry Lewis Hulbert won the Congressional Medal of Honor from his efforts in the Samoan civil war. By the time of his death at age 52, he had accumulated five medals honoring his service in war. He was promoted to captain on the battlefield by Gen. Black Jack Pershing. (LOC.)

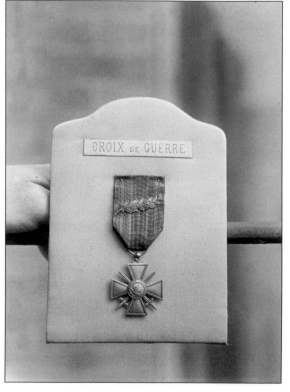

Hubert, one of the most highly decorated Marines in the history of the Marine Corps lived in Riverdale Park with his wife, Victoria, and infant daughter Lilian Lea. At age 52, he was the first man to wear the Marines' prestigious gunner insignia. He was killed at Mont Blanc Ridge on October 5, 1918, the 2nd Division's bloodiest single day of the war. France posthumously awarded Hubert the Croix de Guerre, that country's most prestigious military award. (LOC.)

The USS *Henry Lewis Hulbert* was commissioned on June 28, 1919, christened by Hulbert's widow, Victoria Hulbert, and launched from the Norfolk, Virginia, Navy yard. The ship was decommissioned in 1935 and recommissioned in 1941 as a seaplane tender. It was docked at Pier 1 at the US submarine base at Pearl Harbor on December 7. The first vessel to open fire on the Japanese attack, its .50-caliber antiaircraft battery brought down a torpedo bomber and damaged two other planes. The ship continued to serve in the Central and North Pacific and received two battle stars for service. It was decommissioned for the last time in November 1945. A gun from the USS *Hulbert* manufactured at the Watervliet Arsenal in New York in 1918 now stands in DuPont Circle as a memorial to Riverdale Park's greatest war hero, Henry Lewis Hulbert. (Above, LOC; below, HARP.)

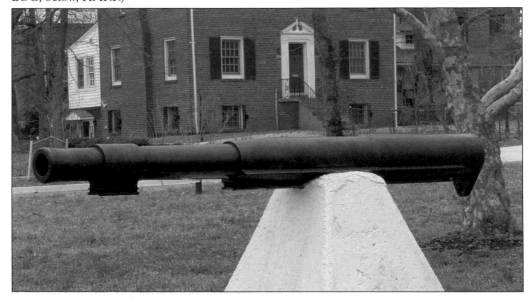

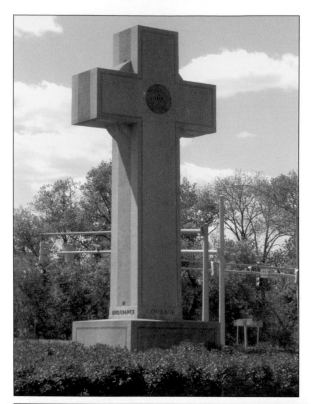

The name of Henry Lewis Hulbert, who is buried in Arlington Cemetery, is cast on the Peace Cross along with those who lost their lives putting themselves in harm's way in defense of their country in World War I. The Peace Cross honors all the fallen soldiers who had lived in Prince George's County. The Peace Cross was constructed in 1925 and is located in Bladensburg, Maryland. Captain Hulbert's rank was bestowed upon him posthumously by Gen. George "Black Jack" Pershing. The Marine Corps instituted an annual award for exemplifying excellence in gunnery honoring Captain Hulbert and presented to the Marine who exhibits the most outstanding performance as a gunner during training. (Both, HARP.)

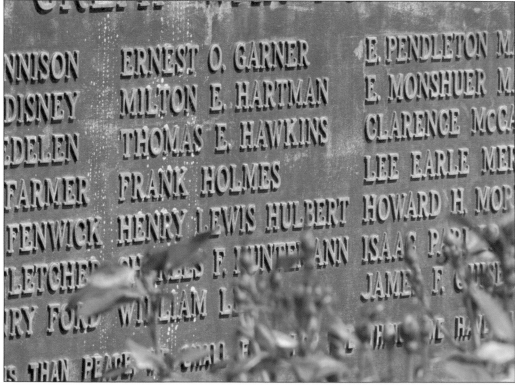

Three

RIVERDALE INC., DEVELOPS

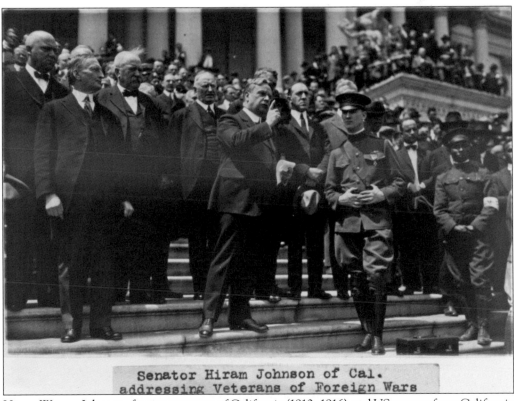

Senator Hiram Johnson of Cal.
addressing Veterans of Foreign Wars

Hiram Warren Johnson, former governor of California (1910–1916) and US senator from California (1917–1945), lived in Riversdale from 1917 to 1929. In 1912, Johnson founded the Progressive Party, known as the Bull Moose Party, with Theodore Roosevelt. That year, he won the party's position as vice presidential candidate, sharing a ticket with former Pres. Theodore Roosevelt. (LOC.)

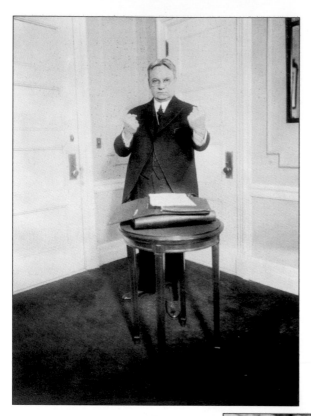

Riversdale owner Thomas H. Pickford invited Hiram Warren Johnson to live there on the verbal agreement Johnson could stay, rent-free, as long as he opposed the League of Nations. Every year, long after the League was a dead issue, Johnson opposed it on the floor of the Senate and sent a copy of the Congressional Record to Pickford as proof of his vigilance. (LOC.)

Hiram Warren Johnson enjoyed living at Riversdale for 11 years. In 1926, Thaddeus Caraway, a senator from Arkansas, bought the mansion. At first, he and Johnson were amicable, and Caraway honored the timeframe of the original Pickford lease. These lease terms became a point of public interest in 1928 and a mounting point of friction between Hiram Warren Johnson and Thaddeus Caraway. (LOC.)

In 1928, Johnson wrote his son a letter recounting a fire that started in Riversdale's carriagehouse-turned-garage. The evening of the fire, Johnson was alerted by Old Spartan, the family dog, to the smell of dense smoke and "a perfect inferno" in the garage. At first, he blamed Thaddeus Caraway for somehow being responsible for the blaze, implying that he was trying to burn him out of Riversdale, but in later letters to his son, he seemed to have recanted this position, noting that there had been a rash of similar fires in Washington, DC, and the Riverdale area. He stayed in Riversdale for the remainder of 1928 and moved out at the end of his formal lease agreement with Caraway in 1929. (Both, LOC.)

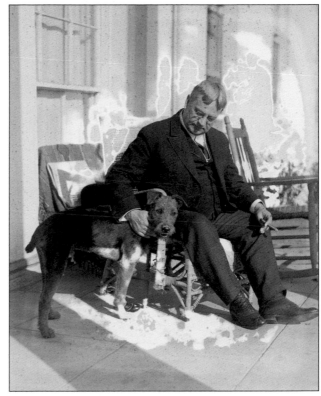

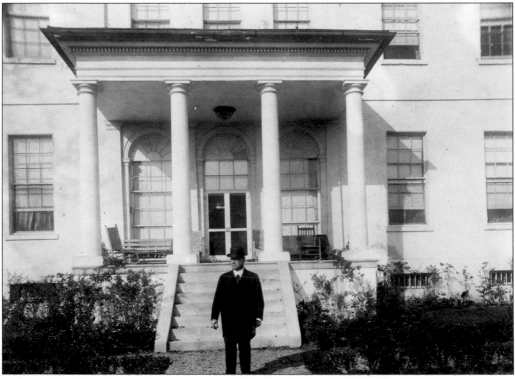

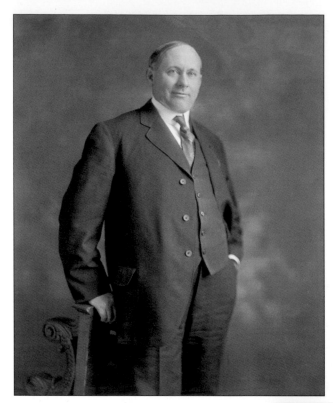

Following Johnson's departure from Riversdale, Senator Thaddeus Caraway and his wife, Hattie Caraway, moved in. Thaddeus Caraway was the epitome of the self-made man. When Thaddeus was three months old, his father, a doctor and Confederate war veteran, was shot and killed as a result of a feud. Thaddeus worked as a railroad section hand and a sharecropper while he put himself through school. He worked as a school teacher while he studied law and was admitted to the bar in the state of Arkansas. (LOC.)

Thaddeus Caraway married Hattie Wyatt in 1902. They had three sons, he served Congress from 1912 to 1921, and he supported America entering the League of Nations. He served in the Senate from 1921 to 1931. Hattie Caraway supported her husband's career and raised their threes sons during those years of their marriage. (LOC.)

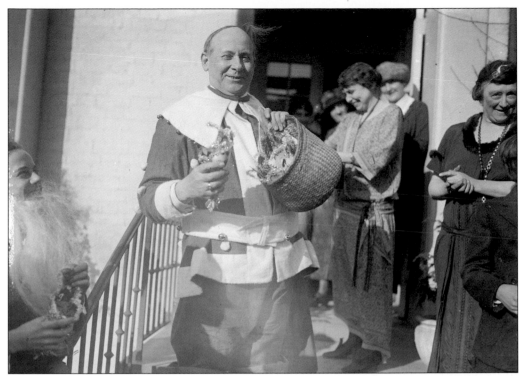

Thaddeus and Hattie Caraway lived at Riversdale together for only two short years, from the end of 1929 until Thaddeus' death in November 1931. He died of complications from a kidney stone operation that caused a ruptured coronary artery. Hattie was left alone with Riversdale to manage. (LOC.)

In the custom of the day, Arkansas governor Harvey Parnell appointed Hattie Caraway to temporarily take her husband's vacant seat in office. She was sworn into office on December 9, 1931. With the backing of the Arkansas Democratic Party, she won a special election in January 1932, making her the first woman elected to the US Senate. (LOC.)

"The time has passed when a woman should be placed in a position and kept there only while someone else is being groomed for the job," is a famous quote made by Hattie Caraway. Hattie Caraway was nicknamed "Silent Hattie" because she seldom gave speeches on the Senate floor, preferring instead to work quietly behind the scenes. (LOC.)

This is a photograph of Hattie Caraway having lunch with Kate Smith, the singer who introduced "God Bless America," written by Irving Berlin, on a radio broadcast on Armistice Day, 1938. Kate Smith had relatives living in Riverdale Park at the time Hattie Caraway occupied the Riversdale Mansion. (LOC.)

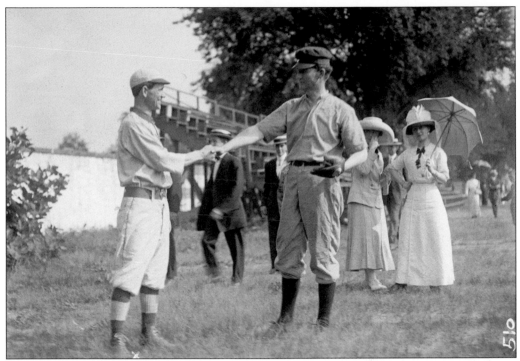

Hattie Caraway lived in Riversdale for a few short years. In spite of the fact that she was a senator, she did not make enough money to keep the house, and it went into foreclosure. It was eventually sold to Abraham Walter Lafferty (left), seen in the photograph above shaking the hand of Congressman Edwin Webb of North Carolina at a congressional baseball game. Caraway was able to keep the back lot of the house, which consisted of the man-made lake and some acreage. Riversdale's man-made lake was originally designed with a natural drainage system and planting to maintain a healthy stock of fish and produce ice for the icehouse. By the late 1930s, time and construction around the mansion caused the lake to degrade into not much more than a swamp and breeding ground for mosquitoes. (Above, LOC; below, M–NCPPC.)

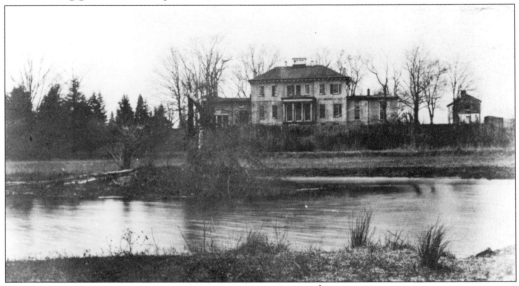

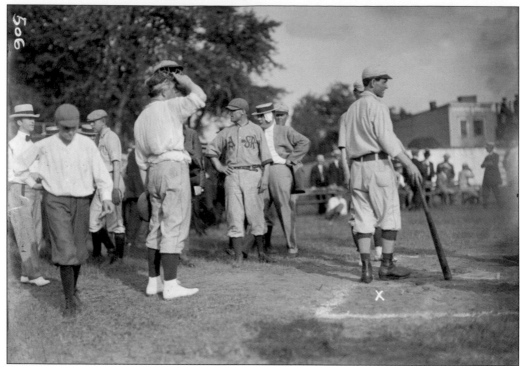

The new owner of Riversdale was Abraham Walter Lafferty, a Republican congressman from Oregon from 1910 to 1914. He was a follower of Theodore Roosevelt and Hiram Warren Johnson's Progressive Party. He was a lawyer and a legislator whose career was defined by a case in which he represented 18 western Oregon counties against the Oregon & California Railroad. Following his congressional career, Abraham Walter Lafferty moved from Oregon to New York to practice law. In 1933, Lafferty, a bachelor, purchased Riversdale from Thomas H. Pickford, who had recently repurchased the property from Hattie Caraway following her foreclosure. Seen above is Abraham Walter Lafferty as a member of the congressional baseball team. The picture below was taken in the 1930s, during a party Lafferty held at Riversdale. (Above, LOC; below, M–NCPPC.)

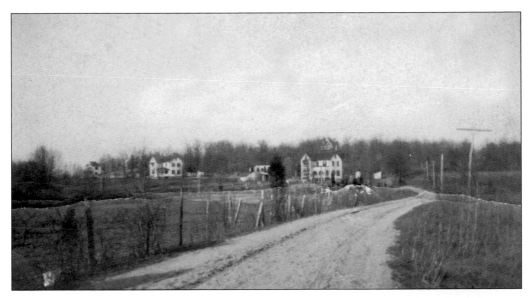

The sleepy bucolic town of Riverdale was waking up to modern times. Gone were the days of leisurely horse-and-buggy rides on country dirt roads. The town was growing up, and by 1920, the residents wanted to be part of an incorporated town. This was largely because the town lacked paved roads, adequate street lighting, piped-in water, storm water management, and sewers. Foremost in the minds of the town's residents was preparing the town for an era of growth and modernization that would accommodate new residential development. (Both, TRP.)

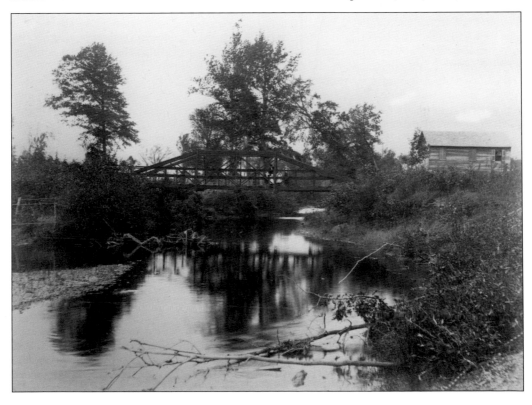

Gov. Albert C. Ritchie approved incorporation of the town of Riverdale on April 17, 1920. Dr. Samuel M. McMillan, a highly respected and beloved town physician, became the first mayor of Riverdale. Dr. McMillan was also a member of the town orchestra and an officer in the Mount Hermon Masonic Lodge, located on Gallitan Street in Hyattsville. He was selected for two one-year terms from 1920 to 1922. (George Denny Jr.)

The town did not have any official municipal buildings. The town government first met alternately in the Riverdale Presbyterian Church Sunday school room or at the Riverdale Park Company office. In 1924, the first firehouse was built. An upstairs room in this building was set aside as a town office. (TRP.)

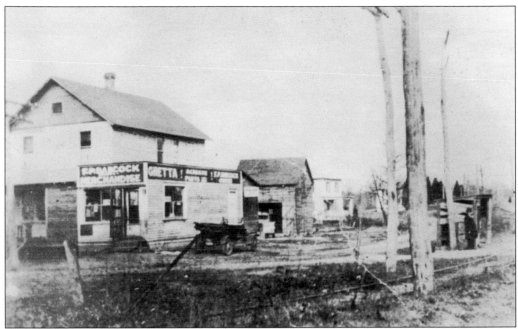

The town was developing into a bustling suburban community. It was now serviced not only by the commuter train and two trolley lines, but also by Baltimore Boulevard, which was a few blocks east of town center and Edmonston Road (now Kenilworth Avenue) and a few blocks west of the river. Commuting by automobile was no longer a novelty hobby for the rich; it was fast overtaking rail commuting and adding to the growth of the town center as a convenient place for Riverdalians to do their shopping. The area around the train station had its own nickel movie house; a Sanitary grocery store (located on the corner of Queensbury Road and Rhode Island Avenue), the forerunner of today's modern Safeway; and Babcock's store, at the corner of what is now Riverdale Road and Kenilworth Avenue in the Gretta subdivision. (Above, LOC; below, TRP.)

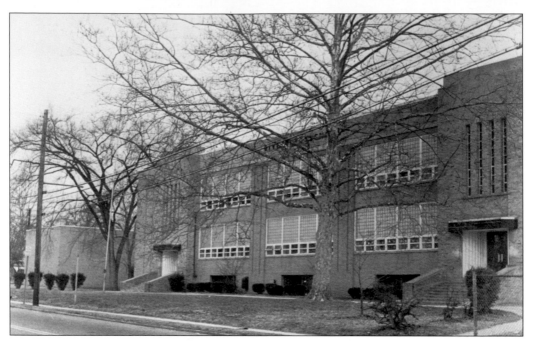

A new Riverdale Elementary School was built at 5006 Riverdale Road to accommodate the growing population of the town. Construction began in 1919, on the corner of Taylor and Riverdale Roads. This was the original location of George Benedict Calvert's octagonal barn. The original school building had six classrooms. By the end of the 1930s, additions to both sides of the building included an auditorium, a cafeteria with a kitchen, a library, and six more classrooms. The student body consisted of grades one through seven. By 1939, there were 500 students enrolled in the school. (Both, TRP.)

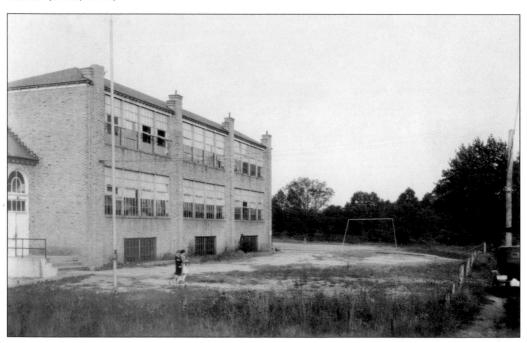

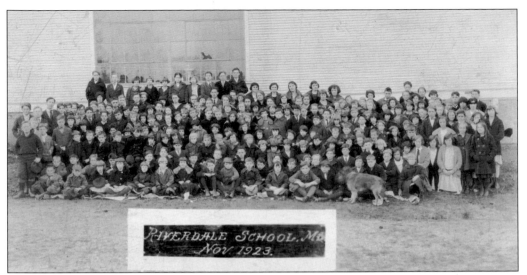

Although Riverdale Elementary School was a modern building for the time, constructed primarily of reinforced concrete, it had a faulty heating system. Students attending the school in the early 1920s and 1930s frequently were sent home on winter days because the classrooms were too cold. (TRP.)

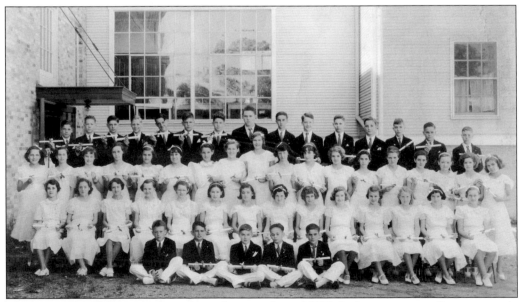

This picture is of the seventh-grade graduating class of 1935. It shows a group of young people dressed in their best, very proud to have reached this point in life and ready to go on to Hyattsville High School. The fine way these children were dressed is a testament to the economic prosperity of the parents of children living in Riverdale Park. (TRP.)

In 1940, Riverdale Park received, courtesy of the Works Progress Administration (WPA), a new sidewalk that extended from Riverdale Elementary School to the bridge over the Northeast Branch. This new sidewalk made a significant safety improvement for the children in Riverdale Park, who no longer had to walk in the road to get to school. (TRP.)

William E. Wedding (left), mayor from 1936 to 1943, received approval for the sidewalk project in April 1940. Mayor Wedding, along with Margret Maddingly, president of the Riverdale Women's Club, shown above, arranged for several WPA projects in the town of Riverdale, including not only the sidewalks and drainage projects but recreational projects as well. (TRP.)

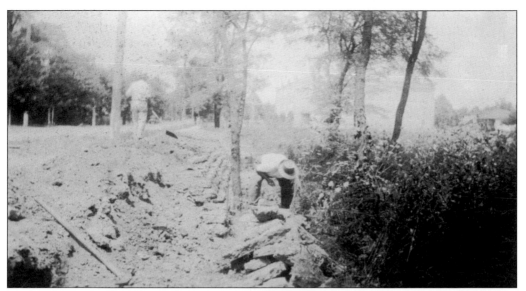

In 1939, Mayor William E. Wedding sent out a petition to the residents who lived along the roads where the sidewalks were to be installed. In November 1939, the petition was returned with more than 51 percent in favor of the WPA-sponsored project. (TRP.)

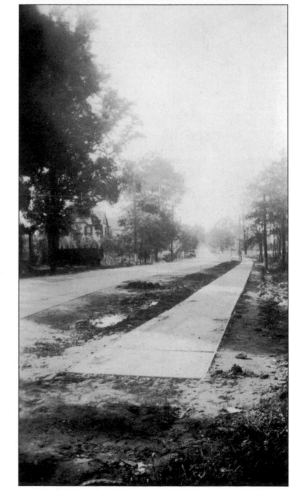

The result of the WPA sidewalk project made a tremendous difference in the quality of life in Riverdale Park and signified the beginning of road and sidewalk modernization. The automobile began to dominate transportation, so the town needed improved roads for automobiles and sidewalks for pedestrians. (TRP.)

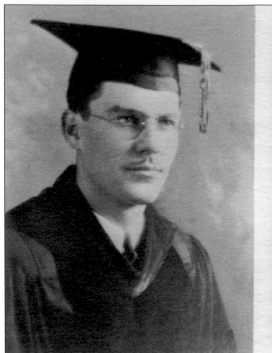
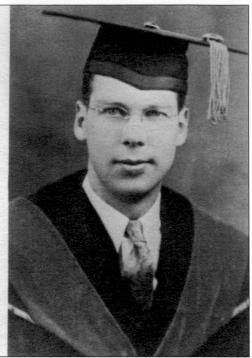
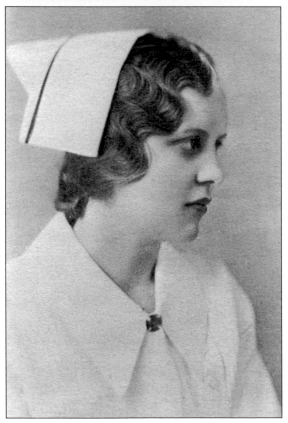

Wendell Malin (left) and his brother, Lawrence Malin (right), devout Seventh-Day Adventists, felt a calling to the medical field from early childhood. They grew up on a farm in Vassar, Michigan, near Battle Creek, and attended medical school in California. Wendell and Lawrence studied medicine at the College of Medical Evangelists in Loma Linda, California. Wendell finished his medical studies first in 1934. He and his wife, Gladys Jacobsen, a recently graduated nurse, moved to the Washington, DC, area with a commitment to establish an independent, religiously based medical facility serving a rural population. First, they established a practice in a Hyattsville house, using the downstairs for offices and examinations and living upstairs. (Both, PGCHS.)

In 1936, Wendell and Gladys started their family practice in a small house in Hyattsville. They planned to establish a community-based medical facility that would serve a larger population. At that time, Prince George's County had no hospital. The Malins purchased a more suitable property on Madison Street (now Queensbury Road), close to the intersection of Baltimore Boulevard. On this site, they built a house with three patient rooms, a small surgery room, and private rooms for the growing Malin family. By December 1942, the Malins were financially able to expand the house into a full-fledged medical facility. Immediately following the attack on Pearl Harbor, the federal government declared a moratorium on all building construction. The Malins were allowed to complete construction only because the footings for their hospital had been poured days before that event. Today, the facility houses Crescent City Center, providing medical and rehabilitative care for patients and residents. (Both, PGCHS.)

Above, the Riverdale Women's Club, established in 1921, pitches in to do its part and to show its pride in the town the women call home. They lived in an era when the residents of the town believed in community effort. Taking responsibility for the way the community appeared was very important to them. These ladies contributed energy not only in beautifying the parks by planting trees but also in organizing welfare programs and promoting education in the community. They worked with Prince George's County social workers and collected food for families in need at holiday times. They maintained a shoe drive for underprivileged schoolchildren, and they raised the funds to purchase fire-protecting coats and boots for the town fire department. Below, Mrs. Oldenburg of the Riverdale Women's Club shares her sombrero from her recent trip to Mexico with here friends. (Both, TRP.)

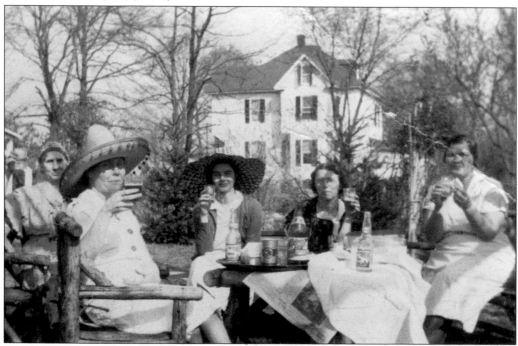

In the summer of 1940, all of the citizens' associations and the members of the town government worked together to beautify and rehabilitate the public spaces. The memorial dedicated to World War I hero Henry Lewis Hulbert was rededicated, and a Memorial Day celebration was held to honor all who had sacrificed in war. The *Washington Times* named this town-wide cleanup as one of the highlights of 1940. (PGCHS.)

The community took a great deal of pride in the way the town appeared. The Riverdale Park Company was no longer in business, and the town was beginning to show signs of neglect. It was also growing rapidly and turning into an important suburban community. The citizens' committees collectively joined in a one-day town clean up. (PGCHS.)

The town had many recreational groups. One of the most popular was a group called the Community Players. Riverdale Park did not have a town community building. Town government and groups used the common room of the Riverdale Presbyterian Church. The Community Players did most of their performing at the Hyattsville Armory. The group was frequently featured in live performances on local radio shows. (TRP.)

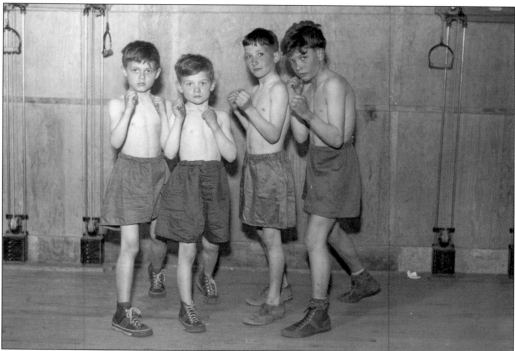

In 1942, Mayor Harry A.L. Barker and Ward 5 councilman Hanson D. Powers created the Riverdale Boys Club, which promoted youth sports, including boxing, basketball, football, and baseball. Several local businesses support the club by providing equipment. In 1969, the original Riverdale Boys Club became the Riverdale Police Boys Club, headed by police chief James L. Woods. (PGCHS.)

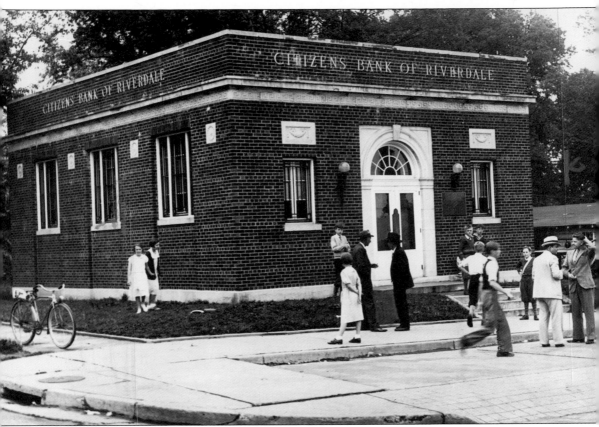

At a time when most of the country suffered economically from the Depression, Riverdale remained prosperous and actually grew. Citizens Bank of Riverdale opened its doors on the corner of Madison Avenue (Queensbury Road) and Baltimore Boulevard in February 1928. The new location was a 30-by-40-foot brick building. The bank was organized by familiar names from families long associated with the area. William P. Magruder was chairman of the board of directors. Others on the board included B.O. Lowndes Wells (University Park), R.A. Bennett and E.W. Riebetanz (both from the Riverdale Park Company), Dr. Samuel M. McMillan (former mayor of Riverdale Park), and C.A.M. Wells (of Hyattsville), who served as the bank's president. The bank began with $25,000 and had $25,000 in surplus cash. By 1931, the board of directors was a virtual who's who of Riverdale Park and Hyattsville society. This is a 1934 picture of the original building from the *Baltimore News-American*. It is from an article describing the aftermath of a "leisurely bank robbery." In this case, a picture is worth a thousand words. (*Baltimore News-American*.)

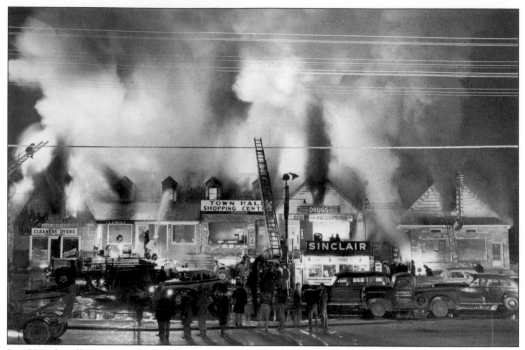

In 1923, the all-volunteer Riverdale Volunteer Fire Department was granted the authority to respond to fire emergencies beyond the limits of the town. Riverdale firefighters coordinated with neighboring fire departments, providing support when manpower was short, either because multiple fires were being fought or the size of the fire required the efforts of more than one fire department. The Riverdale Volunteer Fire Department was well known for its ability to integrate with neighboring departments for efficiently eliminating fires. The fire department won numerous awards, including the Tri-County Championship and the Livingston Cup for open hookup competition. Seen here is the Riverdale Volunteer Fire Department working with the College Park Volunteer Fire Department, extinguishing a major fire at the Town Hall Shopping Center on Baltimore Boulevard in College Park, Maryland. (Both, TRP.)

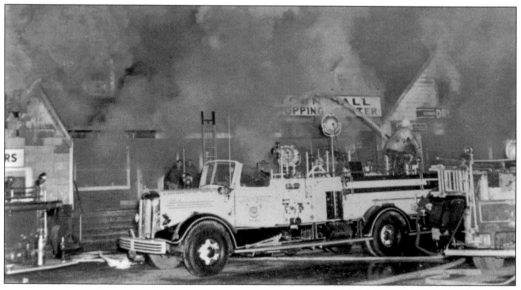

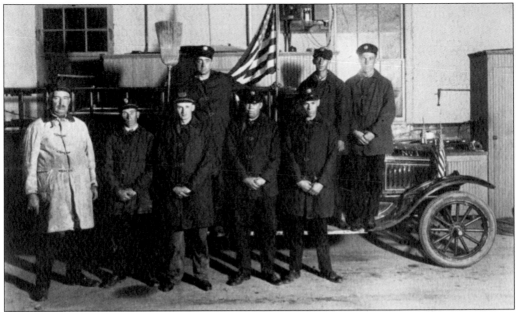

This picture shows Riverdale's first official fire chief, William C. Grey, posing with his men in front of the town's prize pumper truck. All of the men are wearing the fire protection coats that were donated by the Riverdale Women's Club. The women's club borrowed money from the First National Bank of Hyattsville to furnish the firemen with boots and helmets as well. (TRP.)

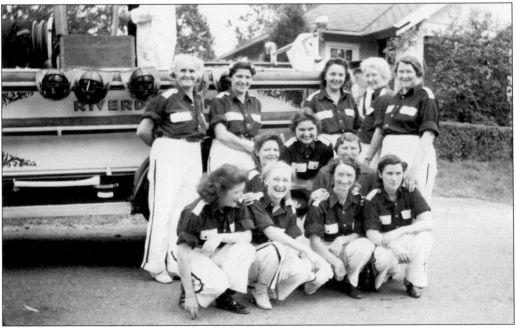

During World War II, when most of the able-bodied men of Riverdale Park were serving in the military, an all-female group of volunteer fire fighters staffed the Riverdale Volunteer Fire Department. Until the time of necessity proved otherwise, this difficult and dangerous work was thought of as male work. Pioneering women like these demonstrated that ability was not necessarily based on gender. (Riverdale Volunteer Fire Department.)

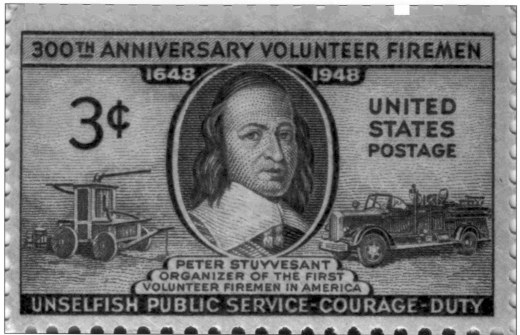

In October 1948, the US Postal Service honored the 300th anniversary of volunteer fire fighters with a commemorative stamp sponsored by Rep. J. Caleb Boggs of Delaware. This stamp featured the fire department's fire truck No. 1. The stamp was formally released in a ceremony that featured J. Caleb Boggs riding in the Riverdale fire truck with the 16-member Riverdale Volunteer Fire Department. (TRP.)

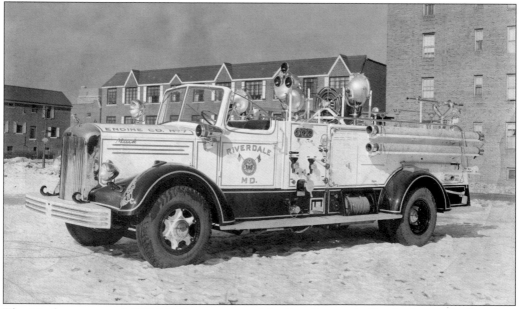

The Mack pump truck 85S-L1115 was a top-of-the-line fire truck. Besides being displayed on the US postage stamp, it was featured in nationwide advertising campaign by the Mack Truck Company. The Riverdale Mack truck was chosen from 50 photographs submitted to the post office for consideration for the stamp. (Mack Truck Museum.)

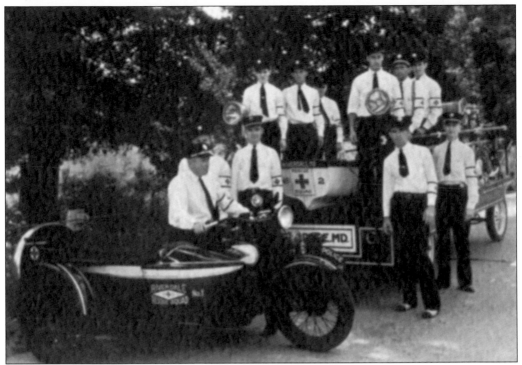

The police department evolved out of the fire department rescue unit. Officer Daniel Herzog was the town's first official law enforcement officer. He served without pay and used his own motorcycle. He used an aluminum boat for river rescue. At the time, aluminum was mainly used in aircraft manufacturing and not commonly available for other purposes. Because of the proximity of the ERCO plant location in Riverdale, which used aluminum extensively, the police were able to acquire this boat. (TRP.)

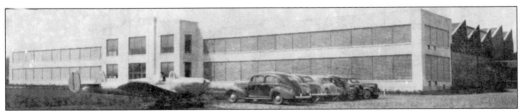

In 1937, Henry Berliner purchased 50 acres of land in Riverdale, Maryland, near the College Park Airport and built the large Engineering and Research Corporation (ERCO) airplane factory and airstrip. One of ERCO's most significant achievements was the development of the Ercoupe aircraft. ERCO was, for two decades beginning in the 1940s, the largest employer in Prince George's County, Maryland. (PGCHS.)

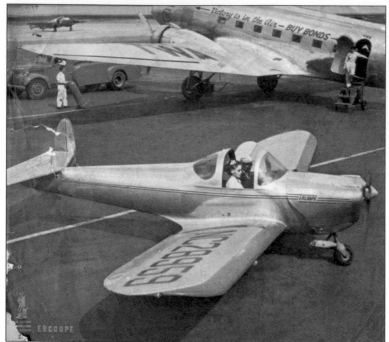

Henry Berliner hired aeronautical engineer Fred Weick to design an aircraft that would be simple, safe, reasonably priced, and appealing to the general public. The Ercoupe does not stall or spin in the air and is easy to maneuver on the ground. The two-seater ERCO Ercoupe 415 went on sale in 1940. Only 112 units were delivered before World War II intervened, stopping civil aircraft production. (HARP.)

After the arrival of World War II, the ERCO plant was quickly converted over to wartime production. Its close proximity to Washington, DC, and the B&O railroad tracks made conversion to war production particularly easy. The plane factory was now under contract with the US government to manufacture critical war machinery, including gun turrets for bombers. (TRP.)

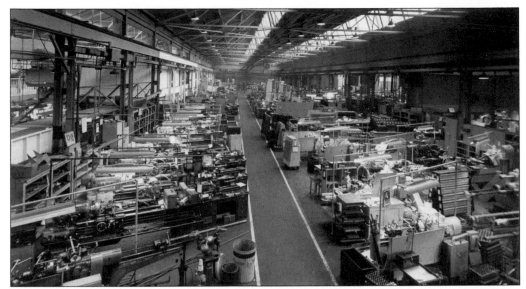

This picture displays the scale of the airplane production at the ERCO plant. During World War II, the production floor operated around the clock. The ERCO newsletter/magazine, which was produced monthly, had columns with bylines designating what shift the writer of the column worked and what area of expertise the writer possessed. (TRP.)

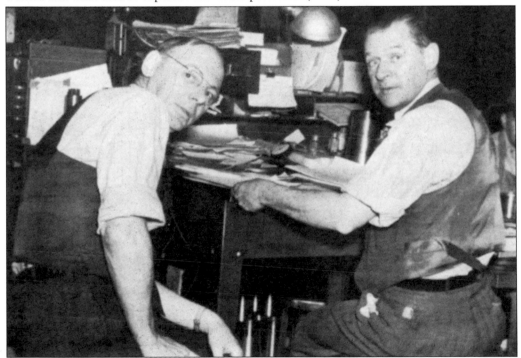

This picture is of Joe Noakes (left), in charge of tool grinding, and Bill Grew, foreman of the ERCO prop machine shop. These two were apparently caught off guard while working out some crucial engineering problem. ERCO employees willingly put in extra hours to assist in the war effort. ERCO won three prestigious Army-Navy E Awards for outstanding production of war materials. (HARP.)

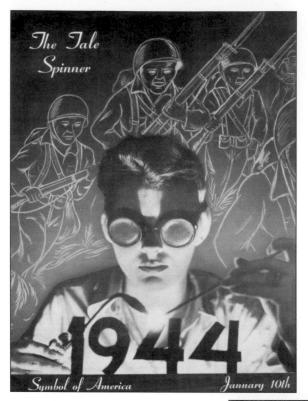

The Tale Spinner

1944

Symbol of America *January 10th*

During World War II, the ERCO plant produced an interdepartmental news letter/magazine called the *Tale Spinner*. This magazine was full of personal accounts of staff members and reenforced the concept of a unified group working for a common cause, the World War II effort. It was produced and edited by workers at the ERCO factory. This cover from January 1944 portrays a female welder, Evelyn Gross. (HARP.)

Each department of the ERCO plant published a friendly monthly account of its work progress, family events, club events, meetings, marriages, and letters from those serving in the military. There were also jokes, cartoons, and want ads looking for used baby furniture and ride shares. One of the magazine editors was Martin Buxbaum, a poet, writer, and philosopher who was deeply influenced by his years working for ERCO. (Kate Buxbaum Prado.)

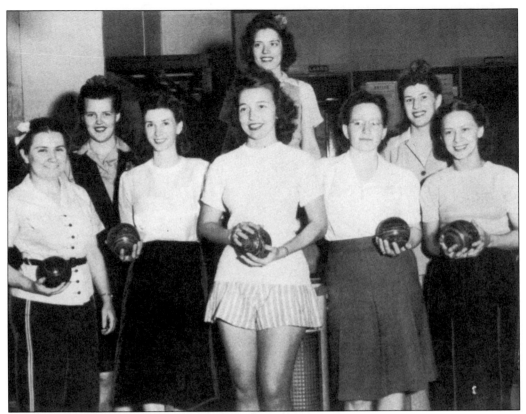

Wartime production at the ERCO plant exceeded expectations. The morale was very high at the factory, and the workers all strove for excellence. Each sector was very tightly knit. Close relationships with fellow workers and a feeling that every bit of energy an employee put into their job were important components toward the war effort. The plant was on a three-shift operating schedule. There was a concerted effort to keep morale high. This is reflected in the many clubs and social activities the employees of ERCO shared during the war. Above is a picture of the dayshift girls' bowling league, which bowled every Tuesday at the Hyattsville Recreation Center. Below is a picture of the "Balcony Gang" (the office workers) bidding farewell to a coworker recently called to military service. (Both, HARP.)

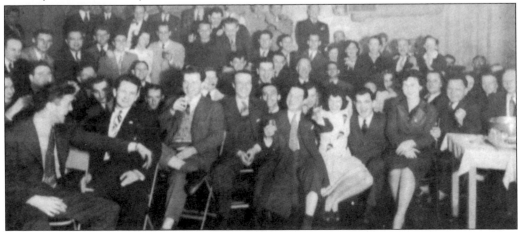

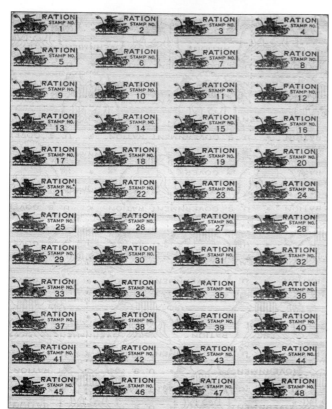

At left is a page from war ration book No. 3, issued by the War Price and Rationing Board in 1943 and used by residents of Riverdale Park. After World War II began, ration books were issued to every citizen in the United States. The books reminded people to "Give your whole support rationing and thereby conserve our vital goods. Be guided by the rule: 'If you don't need it, don't buy it.' " (HARP.)

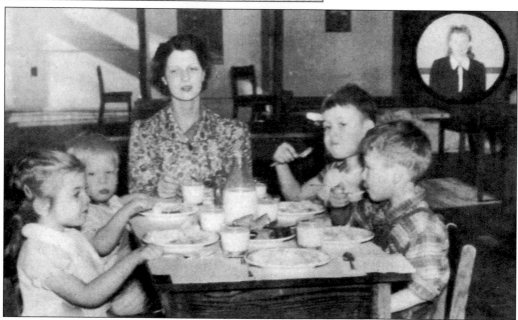

In 1944, the ERCO factory offered its essential defense-industry employees a day-care center, located in the McAlpine House. It was open from 7:30 a.m. to 6:00 p.m. and charged $3 a week per child. It was financed by federal funds. Following World War II, it took decades before day care once again became standard in this country. (HARP.)

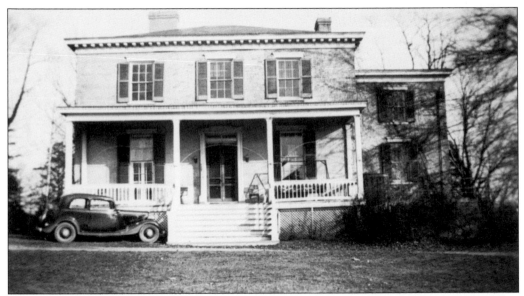

World War II put a moratorium on building construction, reserving all materials for the war effort. That left a critical housing shortage in Riverdale Park. The McAlpine estate, located directly across from the ERCO plant and once the home of Charles Baltimore Calvert (son of Charles Benedict Calvert), was chosen by the Allen Dwelling Authority, a federal government agency, for a 500-unit temporary dwellings project. (PGCHS.)

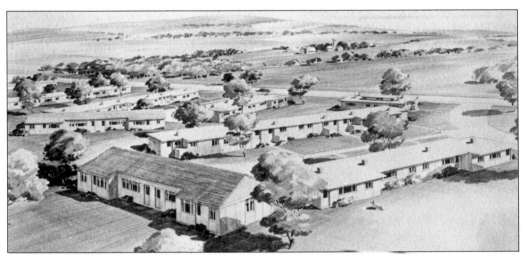

At first, it was speculated that the Calvert Homes project would not materialize. Several other locations were among the choices for the project, but because of the proximity to the ERCO plant and the critical need for workers' housing, the temporary buildings were erected. The housing served workers during the war and later as housing for returning GIs attending the University of Maryland. The development never measured up to the architectural rendering shown above. (National Capital Housing Authority.)

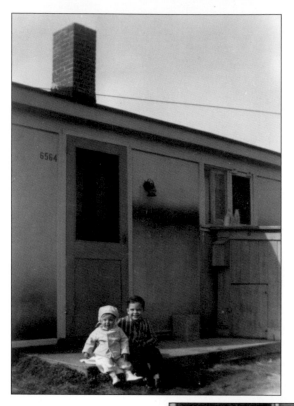

Following World War II, many veterans took the opportunity offered by the US government to reach their full potential by attaining a higher educational degree. James T. Lynch, who served in a US Army tank division, survived being a prisoner of war in Germany and began a new life with his wife, Jacqueline, in Calvert Homes. Pictured at left are Michael J. Lynch (left) and James P. Lynch (right). (Lynch family.)

After finishing his master's degree at the University of Maryland, James T. Lynch (far right in back) had a career working for the Department of Navy, developing its Pioneering Apprenticeship program. He served as the president of Washington, DC, chapter of the Disabled Veterans Association and the local PTA president. Pictured from left to right are Michael, Dennis, Donald William P., Jacqueline A., and James P. Lynch. (Lynch family.)

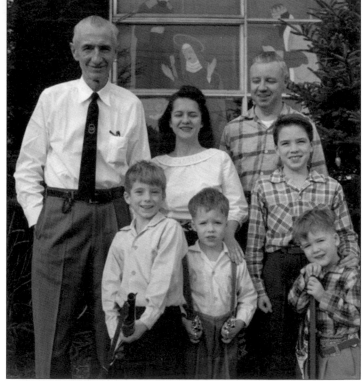

Despite the conditions of the Calvert Homes project, many people have fond memories of their childhoods spent there. In the early 1950s, the Calvert Homes temporary dwellings housed many young families and were essentially overflow dormitories for married students and their families. Seen here and below are children enjoying their Halloween costumes. (Jandolin Marks.)

This picture gives a good idea about the camaraderie the children of the baby-boom years had with each other. The Calvert Homes project was not an ideal housing situation, but for many children, it offered a chance to experience the natural beauty in the woods around Riverdale Park. (Jandolin Marks.)

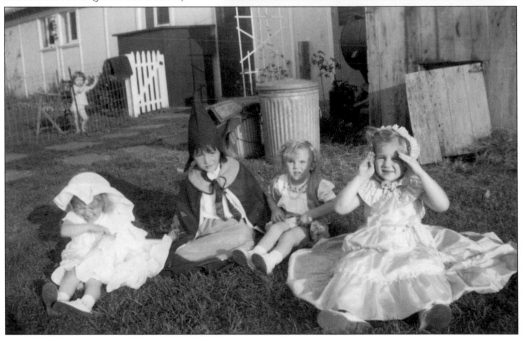

By the end of the 1940s, Abraham Walter Lafferty (fourth from left) was negotiating with the Maryland–National Park and Planning Commission to sell Riversdale. For many years, he tried unsuccessfully to persuade Hattie Caraway to sell him Riversdale's backyard lake and surrounding acreage. Always true to her support of the common man, she finally sold the property to a developer of low-income housing. (M–NCPPC.)

Abraham Laferty is standing to the left in this picture on the front steps of the Riversdale Mansion. Finally, he had reached an agreement with the Maryland–National Capital Park and Planning Commission to buy Riversdale. The historic home of the Calvert family would start out the 1950s as the commission's new headquarters. (M–NCPPC.)

Four

COMMUNITY SPIRIT

The 1950s was a boom time for suburbs in Prince George's County. With prosperity and rezoning, the county experienced a period of expedited development. The era brought a new building and a new name to the Citizens Bank of Riverdale. It was now the Citizens Bank of Maryland, "conveniently yours." This picture was taken before East-West Highway divided the town. (PGCHS.)

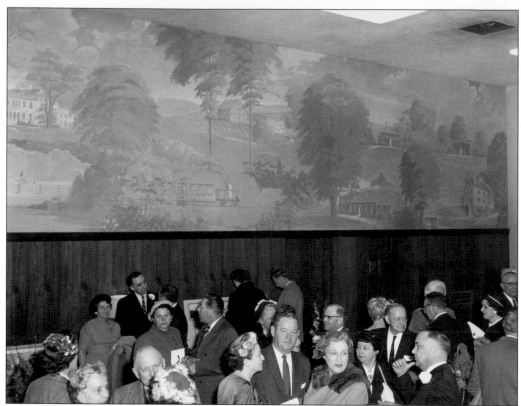

The new Citizens Bank of Maryland commissioned Maryland artist H. Warren Billings to paint a mural that filled the entire front lobby. This mural depicts notable historic homes throughout Prince George's County. It is 43 feet long and took almost a year to complete. The historic homes shown are Riversdale, Belair, Jones Mill, Montpelier, Dower House, and Poe Hill. (PGCHS.)

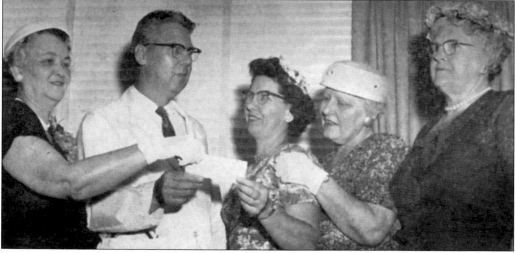

The Riverdale Women's Club made a monetary donation to support Leland Memorial Hospital every year. Most of the women who lived in the northern part of the county had children born at Leland Memorial Hospital and felt a debt of gratitude to the Malin brothers. Though small, Leland provided a great community service to the neighborhood. (PGCHS.)

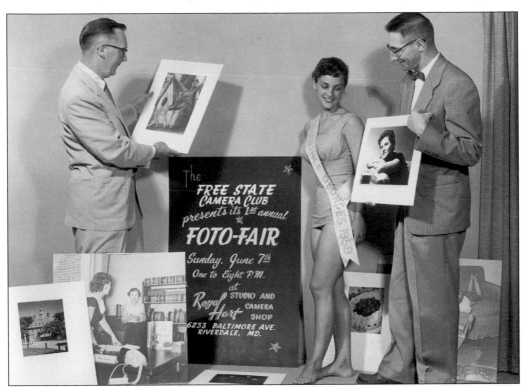

The Royal Studio and Camera Shop
was located at 6233 Baltimore Avenue.
The photographers from this studio
recorded many community events for
local newspapers in Prince George's
County in the 1950s. This picture
is a publicity shot for a photography
competition that features Miss Prince
George's County 1959. (PGCHS.)

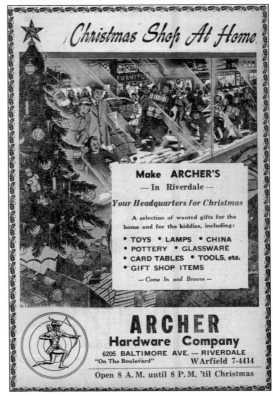

"Make Archers your headquarters in
Riverdale," reads this ad from the mid-
1950s. Archers Hardware store was
located in the building that is today's
Calvert House restaurant, a favorite eating
establishment in the town of Riverdale
Park. It is located across the street from the
former Citizens Bank of Maryland building
on Baltimore Boulevard, which now houses
the Dental Group and the Washington
Lighthouse for the Blind. (PGCHS.)

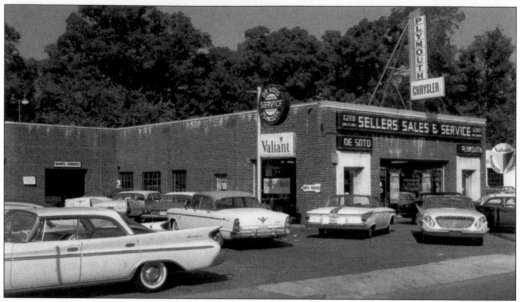

Other businesses along the Route 1 corridor in Riverdale Park also started to develop significantly. One of these was the Resteroff Motor Company, located on Baltimore Boulevard near the corner of Queensbury Road and Riverdale Road. This business sold Studebakers. Mr. Resteroff also owned the Riverdale Garage, a longtime fixture on Baltimore Boulevard. (TRP.)

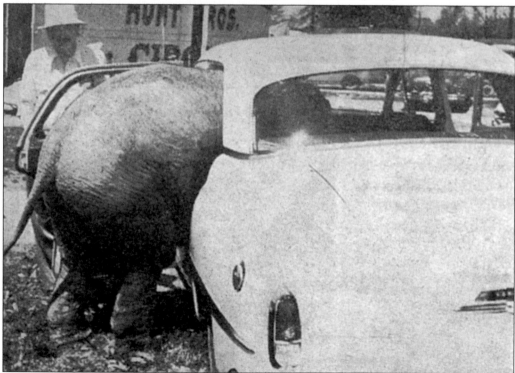

In 1950, when the Hunt Brothers Circus came to Riverdale Elementary School, it made a stop in town. The trainers let the elephants out for a little exercise. As a publicity stunt, the automobile dealership tried to see if they could get an elephant to fit into a Desoto. (PGCHS.)

William W. Chambers developed his chain of funeral homes in the Washington area, billing his company as the "World's Largest Undertakers." The Chambers Funeral Home in Riverdale Park, Maryland, located just off Baltimore Boulevard on Cleveland Avenue, has been a town fixture since the 1920s. It occupies one of Riverdale Park's oldest and most elegant homes. (Thomas Chambers.)

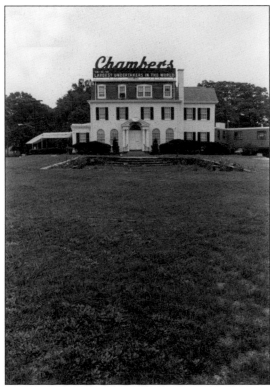

William W. Chambers was a phenomenal self-made businessman. He preferred to be called a "revolutionist" in the funeral industry. Chambers began business in a livery stable, which he advertised with pride, much to the dismay of others in the funeral industry. He was a World War I veteran and a Veterans of Foreign Wars (VFW) member. He helped develop the World War I memorial at Cleveland Circle in Riverdale Park. (Thomas Chambers.)

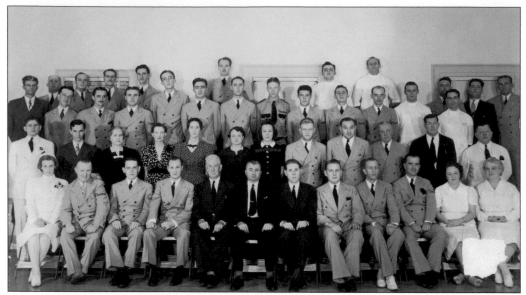

This is a picture of the staff of Chambers Funeral Home. When William W. Chambers's proclamation that his business was the "World's Largest Undertakers" was challenged by the Federal Trade Commission (FTC), he acknowledged that there were a few other undertakers with businesses as large as his in other countries and changed the company slogan to read, "One of the Largest Undertakers in the World." (Thomas Chambers.)

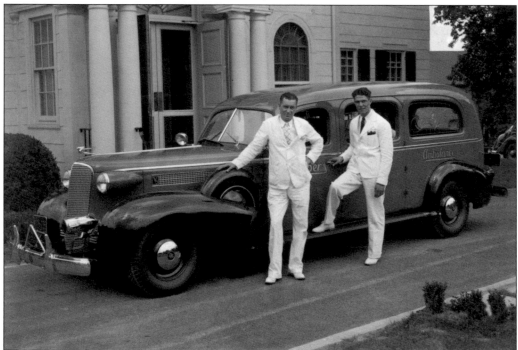

William W. Chambers always used the top-of-the-line hearses in his business. They were called private ambulances. He always preferred a Cadillac. Chambers felt that these cars presented the classiest image for the funeral. They guaranteed that anyone having a funeral through the Chambers Funeral Home would be going out in style. (Thomas Chambers.)

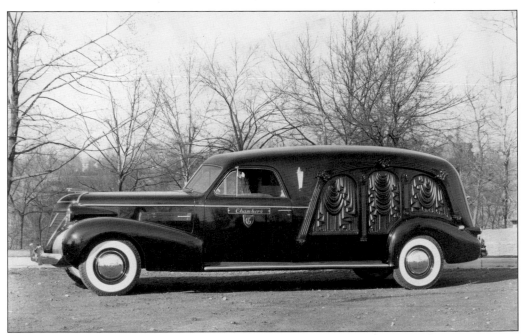

The majority of Chambers Funeral Home hearses were Cadillacs. This was the vehicle of choice for several reasons. Cadillac built a vehicle that came equipped with what the company called a commercial chassis. This was a strengthened version of the long-wheelbase, Fleetwood-limousine-style frame, designed to carry the extra weight of elaborate bodywork and a rear deck and cargo. The rear chassis was considerably lower than the passenger Cadillac car frame to ease loading and unloading from the rear of the vehicle. Cadillac would ship the chassis to the hearse builder, who would custom-complete the vehicle. The wood in the above vehicle was imported from Africa and hand-carved. The round opera window and the stretched-out S on the side of the hearse—called a landau bar—are a nod to the original horse-drawn hearses of the past. (Both, Thomas Chambers.)

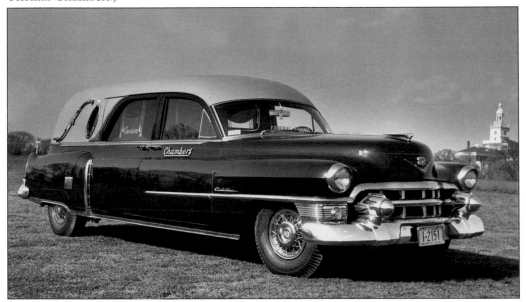

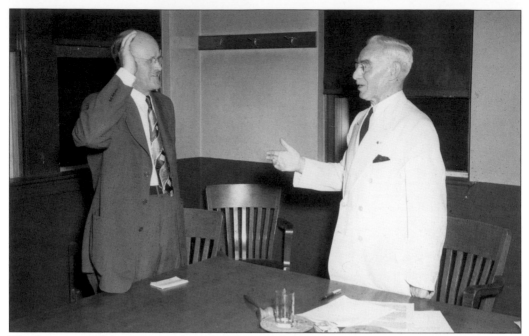

The first mayor of the 1950s, Fredrick W. Waigand (left) is shown being sworn in by former mayor Harry A.L. Barker. Waigand served from 1949 to 1953. In 1951, Mayor Waigand was responsible for legislation that allowed financial compensation to be paid to the mayor and town council members. The mayor received $50 a month, and council members received $25 a month. (PGCHS.)

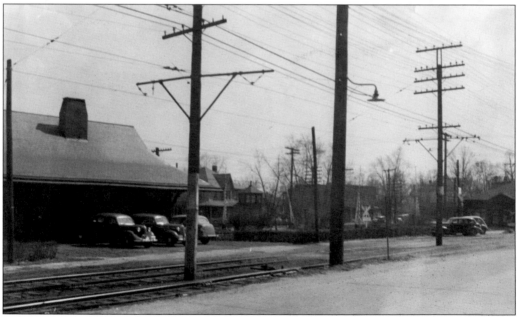

Accelerated growth in Prince George's County presented Riverdale Park with an increased amount of traffic through the town, primarily from the growing communities of New Carrolton and Hyattsville. Riverdale and Queensbury Roads saw huge backups during rush hour. The at-grade crossing at the intersection of Queensbury Road and Rhode Island Avenue was particularly problematic. (PGCHS.)

The new development in the area surrounding Riverdale Park as well as a substandard storm water management program in the town resulted in increased flooding from the Anacostia River. There had always been a periodic spring and fall flooding, but the frequency and severity progressively increased and with that the damage to both private and public property. (TRP.)

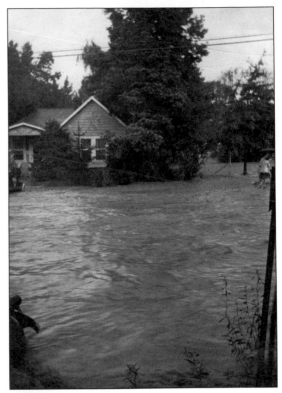

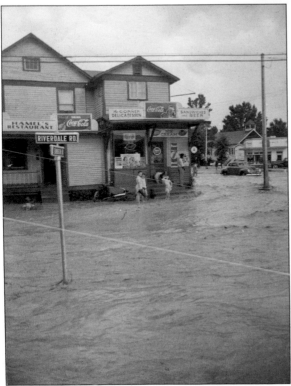

The low-lying area around Riverdale Road and Kenilworth Avenue was a frequent site of major flooding. The river would overflow its banks onto Tanglewood Drive and leave massive quantities of debris on the road. The channelized tributaries eroded, causing parts of the road to collapse and homeowners to lose part of their property to erosion. (TRP.)

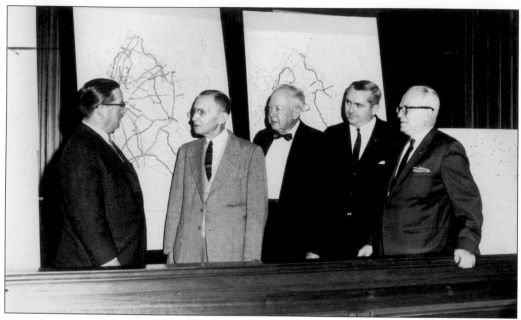

Claude Warren (second from left) was the first mayor to win on a write-in vote. He was determined to remedy the town's disastrous flooding. It was 52 years earlier that he had married Carrie Blundon, daughter of Joseph Blundon, first manager of the Riverdale Park Company. After receiving his law degree from Georgetown University, Warren became the second manager of the Riverdale Park Company. His friend Barry Goldwater (far right) attended this flood control meeting. (PGCHS.)

As mayor, Claude Warren ran the town much as he previously had as the manager of the Riverdale Park Company. He was involved with everything from day-to-day administrative functions to public works projects. A key accomplishment of his administration was arranging a major flood-control project. Seen here is Governor McKeldin making a speech with the Army Corps of Engineers, which implemented the flood control project. (PGCHS.)

By 1954, the Calvert Homes project had been removed. McAlpine was left to deteriorate, and part of the land was redeveloped as a postal facility and a new Army Reserve building. Claude Warren is shown in this picture, taken in August 1959, breaking ground with the top Army brass. (PGCHS.)

Claude Warren gave 60 years to Riverdale Park. Major events in his life include Joseph Blundon being killed by a train; persuading the B&O Railroad to install at-grade gates at Queensbury Road; organizing blood drives in both world wars; his wife's death from influenza; his son's success as a physician; the demise of the Riverdale Park Company; a successful real estate career; and 11 years as mayor of Riverdale Park. (PGCHS.)

Riverdale Park's rich mixture of residents has included a select group of artists, photographers, painters, writers, and musicians. All have gained inspiration form the natural beauty that surrounds them in the town. Martin Buxbaum, shown here with his dog Brownie, was a poet, artist, and photographer who lived in town and worked as an editor for the *Tale Spinner* newsletter/magazine published by ERCO. He was Maryland's poet laureate in 1967. (Kate Buxbaum Prado.)

Martin Buxbaum wrote his first two books in the years he spent in Riverdale Park. *The Underside of Heaven* and *Rivers of Thought*, which sold more than 160,000 copies, were mixtures of inspirational thought, poetry, and photographs about his family, friends, and nature. Even after he and his family moved from the area, his wife returned to Leland Memorial Hospital to have all eight of their children. (Kate Buxbaum Prado.)

Juan Ramón Jiménez won the Nobel Prize for Literature in 1957. He and his wife lived at Queensbury Road. He was an exile from Spain and an internationally recognized poet and thinker. He and his wife lived in a home on Queensbury Road near Leland Memorial Hospital. (HARP.)

Juan Ramón Jiménez and his wife, Zenobia Camprubi, both taught at the University of Maryland. While living here, he wrote an ode to the beautiful trees in the park called "The Quaking Aspens of Riverdale." The language building located on the campus of the University of Maryland is named after Jiménez. (HARP.)

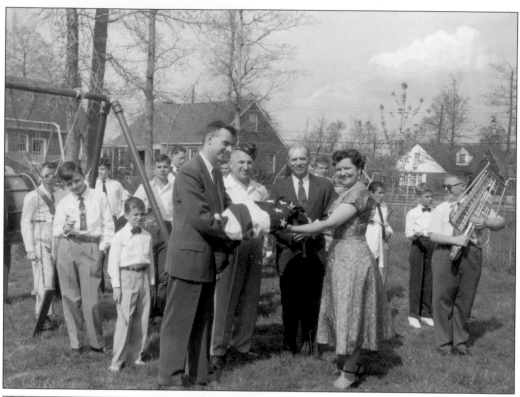

Following World War II, a huge influx of people from the Deep South to the Appalachian Mountains migrated to Washington, DC, seeking work. The social upheaval caused by the Great Depression and World War II made it easer for them to abandon the traditional rural ways of life. Many brought family and friends with them, pursuing opportunities offered by employment with the federal government. Prince George's County, and Riverdale Park in particular, was a popular migration point. The number of affordable homes in the area and the rural setting, similar to the towns they left behind in the South, offered comfortable familiarity and a place to live and mingle with an ever-growing number of like-minded friends. (Both, PGCHS.)

A vibrant music industry that catered to Southern taste developed in the Washington area. Many musicians from the South settled in the neighborhoods in northern Prince George's County. Bluegrass musicians seemed to prefer Riverdale Park. Featured here are internationally renowned Bill Harrell and the Virginians. Bill Harrell (seated in front) was born in Southwest Virginia and grew up in Riverdale Park. He attended Bladensburg High School and graduated from the University of Maryland. (PGCHS.)

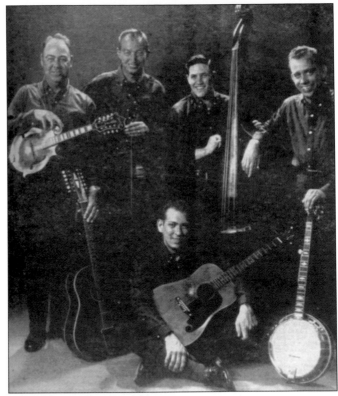

Bill Harrell's father, "Pappy" Bill Harrell Sr., was the councilman for Ward 6 for seven years. Before moving to Riverdale Park, he had performed in minstrel shows, and his wife played piano. The grandmother gave "Pappy" Bill Harrell's son a guitar when he was nine. The Harrell family lived at 6044 Riverdale Road, just one block east of Tanglewood Drive and the Anacostia River. (PGCHS.)

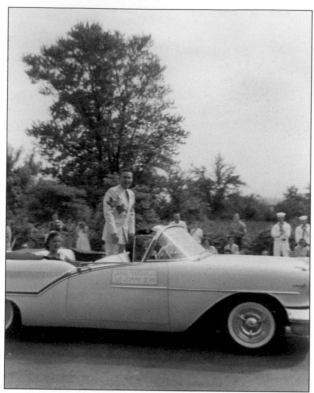

Jimmy Dean, shown here at a local parade, emceed *Town and Country Time*, Connie B. Gay's television show. Jimmy Dean lived in northern Prince George's County. He was part of a group of performers including Bill Harrell, Roy Clark, Roy Buchanan, Link Wray, Chick Hall, Patsy Cline, Wanda Jackson, Big Al Downing, Bob Luman, Charlie Daniels, and others who lived in the county and performed at local clubs. (Emily Fanning.)

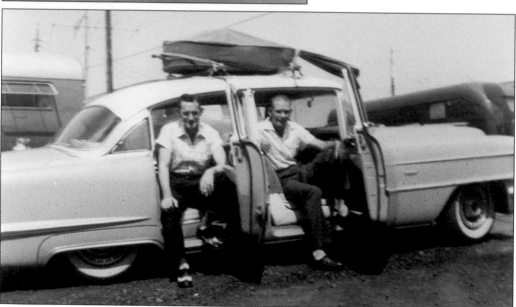

After graduating from the University of Maryland, Bill Harrell played mandolin with Don Reno and Red Smiley's Tennessee Cutups before serving in the Army. Seen here are Dan Reno (left) and Red Smiley (right) Don Reno was an unsurpassed master of the banjo. Arthur Lee "Red" Smiley played guitar and sang lead. Their hits included "Using My Bible for a Road Map," "Don't Let Your Sweet Love Die," and "Feuding Banjos," renamed "Dueling Banjos" for the movie *Deliverance*. (Ronnie Reno.)

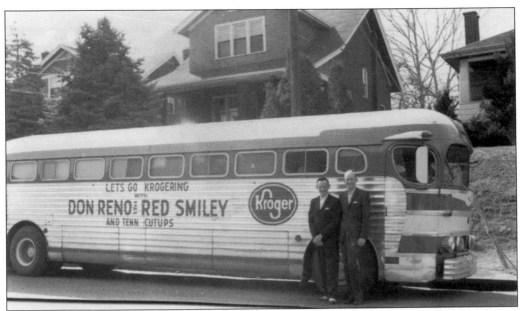

The Tennessee Cutups had a television show sponsored by Kroger's Grocery. By the mid-1960s, health issues forced Red Smiley to retire. Bill Harrell and Don Reno formed a musical partnership that lasted into the 1970s. Red Smiley was able to return and perform with the group a bit, but his health continued to decline. He passed away in 1972. Don Reno lived in Riverdale Park, next door to Bill Harrell, for about 11 years. While living in Riverdale Park, Reno wrote "The Riverdale Flash," a song inspired by the infamous flash flooding. Noted mandolin player Ronnie Reno, Don's eldest son, lived with his father in Riverdale Park for a year. At that time, he met his wife on a blind date. She taught at Wildercroft Elementary School with Bill Harrell's wife. Below are Ronnie and Don Reno. (Both, Ronnie Reno.)

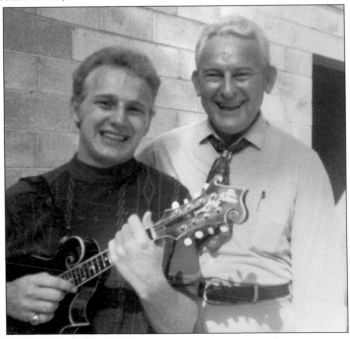

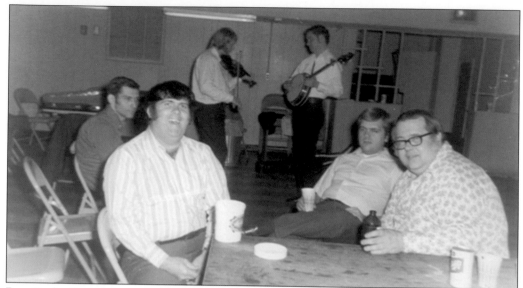

Buzz Busby, front left, is considered to be one of the greatest mandolin players of all time. Busby gave up a full-time career in the FBI for a career as a bluegrass musician. Ed Ferris, front right, is best known as one of the finest stand-up bass players in the area. They both lived in and around Riverdale Park for over 40 years. (Tom Mindte.)

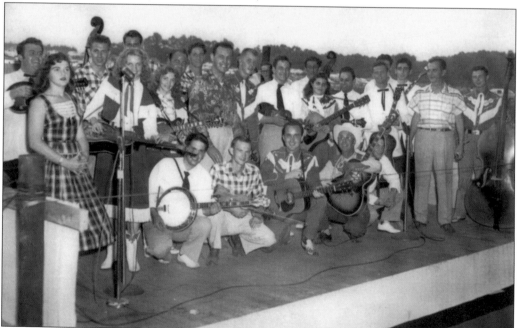

This picture shows the first-, second-, and third-place winners for vocal, fiddle, band, banjo, and miscellaneous at the National Country Music Championship of 1956. From left to right are (kneeling) Pete Kuykendall, Carl Nelson, Jimmy Case, Ernest V. "Pop" Stoneman, and unidentified; (standing) Buzz Busby, unidentified, Bill Harrell, Peggy Stoneman, Roy Self, Donna Stoneman, Smiley Hobbs, Donnie Bryant, unidentified, Scott Stoneman, unidentified, John Hall, Vance Truell, Vallie Cain, Bennie Cain, Charlie Waller, unidentified, Paul Champion, Connie B. Gay, and Jimmy Stoneman. (Bluegrass Museum.)

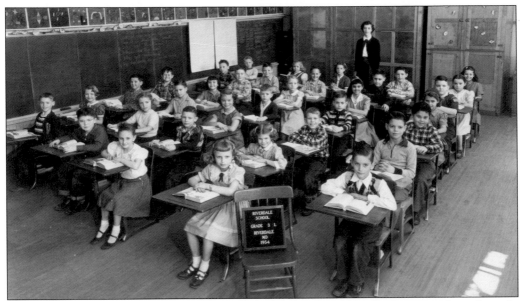

Children in the town of Riverdale Park attended the elementary school in record numbers. In this picture from 1952, John McCord is smiling by the wall. His father, Jack McCord, went on to be the fire chief of the Riverdale Volunteer Fire Department. Jack's picture is featured on the front cover of this book. (John McCord.)

The members of the Riverdale Junior and Senior Champion Teen Club bowling team exhibit the many trophies they won. From left to right are (first row) Phyllis Davidson, Donna Kuehne, Pat Thomas, Carolyn Hurd, and Vicki Hendrix; (second row) Jack McMullen, Bob Taylor, Tommy Kane, Nancy Taylor (manager of the senior team), Gene McDonald, and Bruce Longworth. (PGCHS.)

Tina Temple, featured here, was a grand champion majorette and baton twirler for the state of Maryland. She went on to compete in other titled events, including Miss Majorette Queen of America. The Riverdale area produced several championship-level baton twirlers in the 1960s. Prince George's County made baton twirling a lettered sport for high school. (PGCHS.)

Riverdale Park was well known for its outstanding baton twirlers. The Riverdale Fire Department Majorettes, represented by Tina Temple, are presenting a piece of the first concrete ever poured in the United States to the Riverdale fire chief. The concrete was a souvenir from the international twirling competition, held in 1959. The girls came in second and third place. (PGCHS.)

Pictured are Annalee E. Reed (left); Mildred L. Anglin (center), the principal of Riverdale Elementary School; and Constance H. Bostick. They were the first women police officers in Riverdale, appointed on January 1, 1954, by Mayor Claude E. Warren. (PGCHS.)

The Maryland–National Capital Park Police are on display in this picture. Riversdale was used as the headquarters for the Maryland–National Capital Park and Planning. Riverdale Park had a strong park police presence in the town. These gentlemen are proudly displaying their police cruisers on the lawn of Riversdale. (PGCHS.)

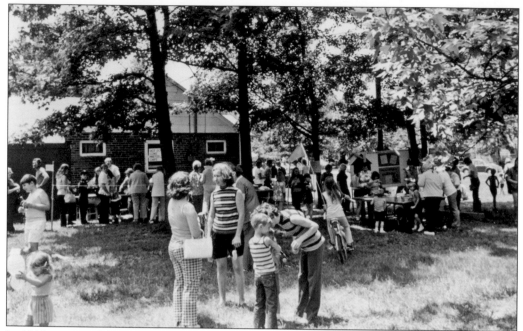

In 1940, as part of the WPA projects, the town expanded the community center and recreational facility. It has been the location for town events and a meeting place for the plethora of committees and clubs in town. In 1964, the building was dedicated to Claude E. Warren for 60 years of public service to Riverdale, including the last 11 years of his life as town mayor. (TRP.)

In this picture from 1959, these two young men are receiving scouting's highest rank. Eagle Scout is being awarded to two Boy Scouts from Troop 252 by Msgr. Thomas Dade of St. Bernard's Catholic Church. St. Bernard's sponsored Troop 252. They received their badges at a ceremony called a Court of Honor at the church. (PGCHS.)

Though there are not many large churches in the town of Riverdale Park, there are a few tucked away on the quiet streets of the town's neighborhoods. The Christian Life Center on Taylor Road, originally the Assembly of God Church, is one and is currently pastored by Rev. Ben Slye. He is a third-generation pastor for the church, built by his grandfather with his own two hands. (PGCHS.)

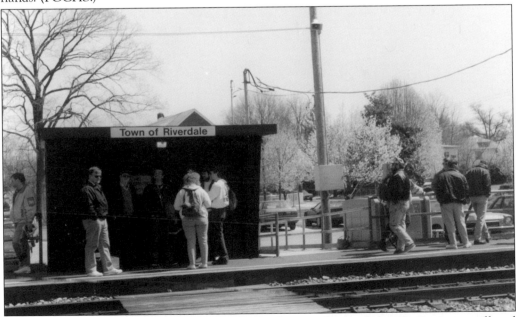

In the 1970s, the Riverdale train stop was not much more than a shelter. It was very small and provided barely any protection from the elements. It sat beside the railroad tracks as an obsolete vestige of former times. Fortunately, by the mid-1990s, the town was experiencing a renewed appreciation for its history, and the CSX Corporation built a new train station that is attractive and functional. (TRP.)

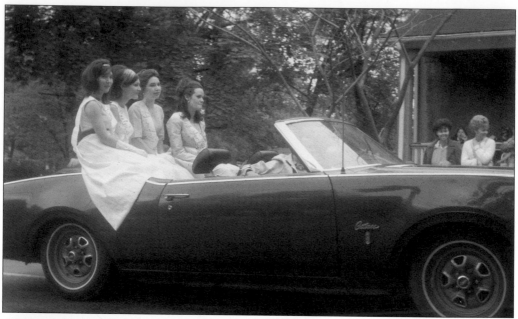

The 50th birthday of Riverdale Park was a town gala event. An elaborate celebration was prepared with parades and parties that lasted for days. It also included a publication that was documented in the town's history, including rare reminiscences of many early residents. The event generated a tremendous amount of pride in the town. (TRP.)

Much-revered Councilwoman Mabelle Munch was born in 1895. As a single parent, she worked for the federal government for over 25 years. She served on the town council from 1970 to 1975. She could often be seen tending the gardens in the town's public spaces. Following her passing in 1988, she was honored by having a park named after her on Queensbury Road near the town center. (TRP.)

Ground-breaking for the town municipal center was held in April 1981. Mayor Guy Tiberio was responsible for arranging construction of the building that now houses the town government, code enforcement department, and police department. Though the building had been planned for several years prior to construction, it was not until Mayor Tiberio that the funding was obtained for the project. (TRP.)

In the late 1970s, Leland Memorial Hospital added a new wing in an attempt to modernize the hospital. Seen here at the dedication ceremony, Gladys Noon Spellman served three terms in Congress and was a popular political figure in Maryland. Spellman is known for her dedicated attendance at citizen meetings and her devotion to constituent service. (TRP.)

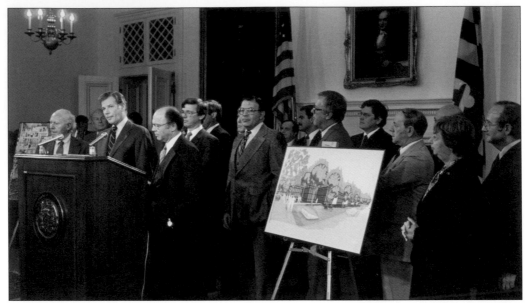

In the early 1990s, plans for construction on the 100 acres of woodland that were once part of the ERCO airplane factory were in the works. The first building erected was the American Center for Physics. Two new roads were cut, and building began. In this picture, Gov. Harry Hughes explains this development. (TRP.)

Throughout the 1990s, Anne Ferguson served as the mayor of Riverdale. She is singularly responsible for most of the special touches that can be seen in the town. The addition of the iconic train station, the clock in town center, and many other improvements occurred while she was mayor of Riverdale Park. (TRP.)

Five

RIVERDALE PARK TODAY

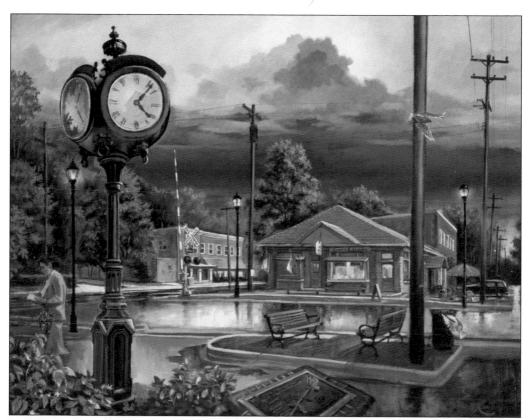

In 1998, a referendum was passed changing the name of Riverdale to Riverdale Park. The original trolley car station located next to the railroad track is one of the most unique buildings in Riverdale Park. For a short, wonderful time, it was the site of the Riverdale Bookstore and Coffee Shop. As depicted in this painting by Gerald King, owners Audrey Bragg and Simon Plog created an oasis where many unusual books, great music, and great company could be found. (Gerald King.)

Gerald King moved to Riverdale Park in 1970. He has worked professionally as an artist for 70 years. Originally from Wisconsin, he comes from a family of artists. Gerald has been both a teacher and a student of the masters his entire life. Over the years, he has uniquely captured the world around him in Riverdale Park in his paintings and drawings. (Gerald King.)

This painting depicts the river and bridge over the Northeast Branch of the Potomac. With his keen eye for detail and love of his natural surroundings, King has captured the look and feel of the land surrounding Riverdale Park. His work is simultaneously timeless and contemporary. (Gerald King.)

Yoko King was born in Chiba City, Japan. She began her dance training at the age of four. She received her dance degree in Japan and moved to the United States in 1958. Since coming to the Washington area in 1970, Yoko Harada King has been the director of Kotobuki Kai, Inc. The group has performed throughout the Washington, DC, area and surrounding cities. (Gerald King.)

The primary purpose of Kotobuki Kai was to locate and utilize national and international artists trained in the art of Japanese dance, stimulate public interest in the art form, and provide a public forum for the performers of the art form. Gerald King has used the dancers and costumes as the subject of many paintings. Seen here is Yoko King. (Gerald King.)

The Archie Edwards Blues Heritage Foundation was established in honor of Archie Edwards, a Piedmont blues great. Originally located in a barbershop on Bunker Hill Road in Washington, DC, it relocated to the trolley car station in Riverdale Park in 2009. There are blues workshops and open jam sessions every Saturday. Shown here performing with a resonator guitar is N.J. Warren (1933–2009), a longtime friend of Archie Edwards. (Don Lynch.)

Featured at right is Michel Baytop, an accomplished acoustic blues musician and well-known artist in the region, performing with a young bones virtuoso, Nicholas Spicer, during the 2009 Holiday Market and Festival of Lights. Michel Baytop is one of the founders of the Archie Edwards Blues Heritage Foundation. (Music on the Rise.)

118

This picture features guitarist and singer Rick Franklin performing with his band. Franklin is keeping the tradition of Piedmont blues alive with his band Rick Franklin and Friends. Rick Franklin is an internationally known performer who conducts seminars on the blues all over the United States and Europe. (Music on the Rise.)

This is a photograph of Chick Hall Jr., one of the greatest guitar players in the Washington, DC, area. He is seen here performing at the Riverdale Park Day event in October 2010. He performed with Mike Tool on drums and his brother Chris Hall on bass guitar. Chris Hall is the former owner of Chick Hall's Surf Room, located in Edmonston, Maryland. (Music on the Rise.)

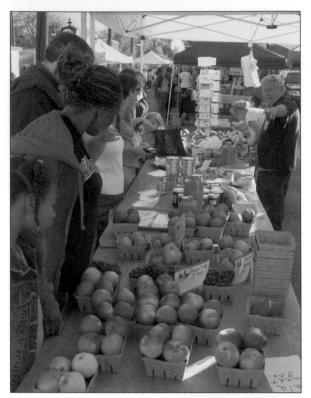

The Riverdale Park Farm Market is, by far, the greatest success of the town. Open every Thursday from April to December since 1997, this unique market is central to the social life in Riverdale Park. Always focusing on farm produce and the buy-local philosophy, it has a steady following of loyal customers from all over the Washington, DC, metro area. (Lance Whitney.)

Every week, the Riverdale Farm Market offers a diverse opportunity for people in the community to have a variety of cultural experiences as well as shopping for farm-fresh food items. The sound stage features the best of local musicians and, occasionally, a celebrity chef. This picture features the market's marvelous live plant sellers. (Patricia Gladding.)

Every winter in early December, the town of Riverdale Park has a special holiday craft and food market, followed by a festival of lights. The Holiday Market always features musical guests that enhance the shopping experience. Riverdale Park has a wide variety of performers, a large selection of gifts, pictures with Santa, and an array of choices for the holidays. Featured in the photograph at right is Marianna Previti, who performed with the Capitol Noir band. In the bottom picture, S&J's restaurant and bar, the longest-operating establishment in the community, can be seen behind Kevin Dudley's and Janine Wilson's performance. (Both, Music on the Rise.)

Riverdale Park has a bounty of beautifully restored vintage cars. These vehicles are proudly displayed at special events held throughout the year. First Place at the Antique Car Show in the Trucks Category at the 2010 Fourth of July celebration was Jim Rogers, shown above with his dog Skipper. Jim Rogers served two tours of duty in Vietnam and now enjoys the peaceful life in Riverdale Park. (Don Lynch.)

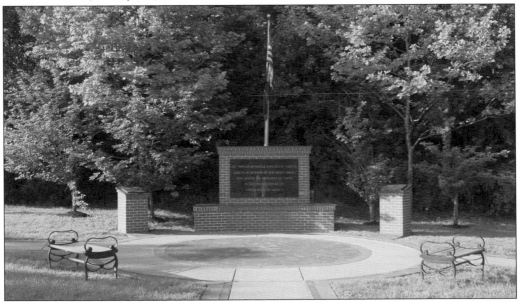

Located across the street from the MARC train station at Lafayette Avenue and the Mabelle Munch Park is the Riverdale Park Veterans Memorial. This memorial represents the veterans from all the wars that this country fought. It is a point of pride, located in the town center and kept neatly landscaped by the town. Every year on Memorial Day and on Veterans Day, the town has a ceremony that honors veterans, and a veterans' Christmas tree is erected every winter. (HARP.)

Chris Benjamin, the original member of the Riverdale Railfans club, is a fixture at the farm market and all Riverdale Park town events. He sets up his extensive train sets and gives children of all ages the experience of model railroading. Benjamin is seen in one of the places he can always be found—by the railroad tracks. (Don Lynch.)

After many years, through the efforts of former mayor Anne Ferguson, the town of Riverdale Park was able to have a train station built to replace the original Victorian station. It is a small brick building with many of the design elements of the original station. It has assumed the status of a symbol for the town. (Lance Whitney.)

Every first weekend in October, the town celebrates Riverdale Park Day. This annual event is like a giant birthday party in the park for the entire town. The fire department and police department join in the fun of the day. Featured here is Nova Johns in the foreground with her son and nephew. Nova Johns is secretary of the Riverdale Volunteer Fire Department and coordinator of the Riverdale Days Committee. In the background are town administrator Sara Imhulse and Chief Tressa Chambers. (Music on the Rise.)

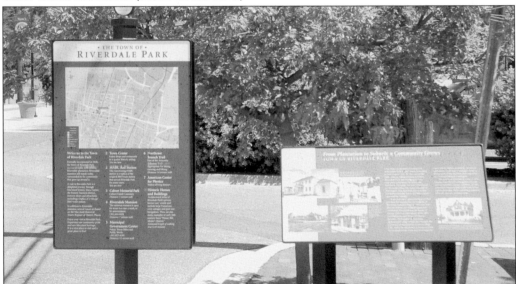

The Anacostia Trails Heritage Area (ATHA) is located in the northern part of Prince George's County. Its mission statement, in part, states that ATHA "helps communities strengthen their economies by developing, protecting, and promoting their cultural, historical, and natural resources." Shown here are two of many ATHA signs designating historically significant locations throughout the Anacostia Trails Heritage Area. (Music on the Rise.)

The Riverdale Park Business Association remains the most active community organization in town. The members of the Riverdale Park Business Association meet once a month and participate regularly in a variety of activates that help to enrich the community, such as Christmas in April and supporting the wounded veterans recovering at Walter Reed Hospital. The group responds with financial donations to worthy causes or in-kind labor. (Audrey Bragg.)

Dumm's Pizza and Dumm's Corner Market, both owned and operated by the Spiropoulos family, have been in operation since the late 1980s. These establishments remained open during the 2010 snowstorm, providing residents with the basic necessities. Soon Dumm's Corner Market will relocate to the corner of Queensbury Road and Lafayette Avenue in a Donald H. Drayer–designed building that originally housed a company producing "black boxes" for the aircraft industry. (PGCHS.)

"In the minds of many people speculation on the future centers on architectural innovations, new modes of transportation, and the capricious path of science and technology. There is no doubt that these kinds of things rightfully command some attention. However, they are not the most important factors in terms of molding the quality of Riverdale's future. The material manifestations of progress cannot guarantee happiness, nor can they guarantee a secure and stimulating community—only people can do this. If the past is prologue, then what we think and do today will surely determine the future . . . One of the biggest challenges of the future is to learn the social and economic techniques needed to preserve our community without destroying its vigor." This quote, from the *Golden Panorama, 1970*, published by the Town of Riverdale for its 50th anniversary, holds true today as it did then. Above, John Wasilik (1925–2011) and Ann Wasilik enjoy their daughter Marianna Previti's performance at Riverdale Park's July 4, 2010, celebration under the bridge in town center. (Jim Atkinson.)

INDEX

www.arcadiapublishing.com

Discover books about the town where you grew up, the cities where your friends and families live, the town where your parents met, or even that retirement spot you've been dreaming about. Our Web site provides history lovers with exclusive deals, advanced notification about new titles, e-mail alerts of author events, and much more.

Arcadia Publishing, the leading local history publisher in the United States, is committed to making history accessible and meaningful through publishing books that celebrate and preserve the heritage of America's people and places. Consistent with our mission to preserve history on a local level, this book was printed in South Carolina on American-made paper and manufactured entirely in the United States.

This book carries the accredited Forest Stewardship Council (FSC) label and is printed on 100 percent FSC-certified paper. Products carrying the FSC label are independently certified to assure consumers that they come from forests that are managed to meet the social, economic, and ecological needs of present and future generations.

FSC
Mixed Sources
Product group from well-managed
forests and other controlled sources

Cert no. SW-COC-001530
www.fsc.org
© 1996 Forest Stewardship Council

Find Your Place in History.